Nuclear explosion

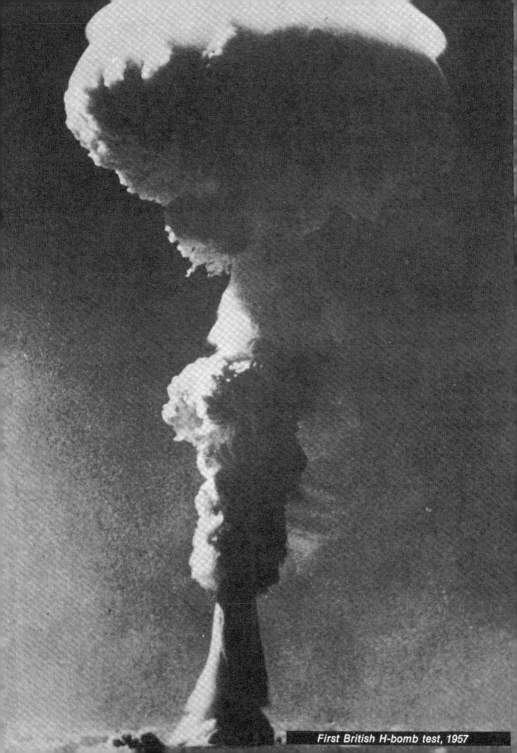

First British H-bomb test, 1957

THIS DOCUMENTATION OF IDEAS
AND CONCEPTS OF A NEW
POLYMORPHOUS REALITY IS
OFFERED AS EVIDENCE OF THE
NEW METHODS AND PROCESSES
THAT WERE INTRODUCED BY
FLUXUS, HAPPENINGS AND POP.
A DEMAND FOR NEW PATTERNS
OF BEHAVIOR - NEW UNCONSUMED
ENVIRONMENTS.

THE ACCENT IN ALL THE WORKS
IN THIS BOOK LIES ON CHANGE-
--i.e. EXPANSION OF PHYSICAL
SURROUNDINGS, SENSIBILITIES,
MEDIA, THROUGH DISTURBANCE
OF THE FAMILIAR.
ACTION IS ARCHITECTURE!
EVERYTHING IS ARCHITECTURE!

THIS DOCUMENTATION OF IDEAS
AND CONCEPTS OF A NEW
POLYMORPHOUS REALITY IS
OFFERED AS EVIDENCE OF THE
NEW METHODS AND PROCESSES
THAT WERE INTRODUCED BY
FLUXUS, <u>HAPPENINGS</u> AND <u>POP</u>.
A DEMAND FOR NEW PATTERNS
OF BEHAVIOR-NEW UNCONSUMED
ENVIRONMENTS.

THE ACCENT IN ALL THE WORKS
IN THIS BOOK LIES ON <u>CHANGE</u>
-- i.e. <u>EXPANSION</u> OF PHYSICAL
SURROUNDINGS, SENSIBILITIES,
MEDIA, THROUGH DISTINK RANGE
OF THE FAMILIAR.
ACTION IS ARCHITECTURE.
<u>EVERYTHING IS ARCHITECTURE.</u>

A NEW LIFE. RÜHM'S WIEN
BUILT OF THE LETTERS IN THE
GERMAN NAME FOR VIENNA —
 HOLLEIN'S AIRCRAFT CARRIER
AS A CITY FOR 30,000 INHABI-
TANTS — OLDENBURG'S ALTERATION
OF THE THAMES —— MY
SUPER HIGHWAY AS A CATHEDRAL
ENVIRONMENT — ARE ALL
UTOPIAS CONTAINING MORE
TRUTH AND VISUALIZATION OF
PRESENT-DAY THOUGHT THAN
THE REPRESSIVE ARCHITECTURE
OF BUREAUCRACY AND LUXURY
THAT IMPOSES RESTRICTIONS
ON PEOPLE. ————
EVERYTHING IS FORBIDDEN.

DON'T TOUCH !
NO SPITTING ! NO SMOKING!
NO THINKING!
NO LIVING !
OUR PROJECTS - OUR
ENVIRONMENTS ARE MEANT
TO FREE MAN. —————————

ONLY THE REALIZATION OF
UTOPIAS WILL MAKE MAN
HAPPY AND RELEASE HIM
FROM HIS FRUSTRATIONS!

USE YOUR IMAGINATION!
JOIN IN..... SHARE THE POWER!
SHARE PROPERTY !

WOLF VOSTELL
COLOGNE 1969

Don't touch!
No spitting! No smoking!
No thinking!
No living!
OUR PROJECTS-OUR
ENVIRONMENTS ARE MEANT
TO FREE MAN. _____
ONLY THE REALIZATION OF
UTOPIAS WILL MAKE MAN
HAPPY AND RELEASE HIM
FROM HIS FRUSTRATIONS!
USE YOUR IMAGINATION!
JOIN IN..... SHARE THE POWER!
SHARE PROPERTY!
Wolf Vostell
Cologne 1969

FANTASTIC

ARCHITECTURE

Wolf

Vostell

Dick

Higgins

Something Else Press

Introduction

Architecture, to the extent that it is an art, is the last art still in a primitive state. Virtually none of the aesthetic revolutions of the 20th century has touched it. We cannot speak of Dada architecture, Tachist architecture, even collage architecture. The main innovations have been structural, as methods of manufacture have become more sophisticated, and in the direction of introducing new materials — ceramic tiles, unusual functions for glass. This is the equivalent, in painting, of introducing a new shade of alizarin crimson or gilt paint, and continuing to make the same old Secessionist or Post-Impressionist commodity. So this man does "new things" with pierced concrete. It is the equivalent of a composer working out his trombone parts well and in an original idiom. The perception of space, the use of space – which is, after all, what architecture is about, since it is in space that we live, that we shelter ourselves, and through which we move when we go from one phase of our activity to another – the function of space has been allowed to remain quagmired in 19th century or pseudo-Marxist or even narodnik assumptions. Such architects as Christopher Alexander have only just begun to escape from the drawing board mentality, the architectural equivalent of easel painting. And architecture as process is only being dreamed of.

Naturally a great deal of this is due to oldfashioned building codes, zoning practices, archaic planning systems such as those of the Ekistiks group or Le Corbusier, and trade union regulations. Since these do not serve contemporary needs, they must be either changed, rejected or bypassed. But in no event should they be allowed to continue to dominate the real needs for creating space, which may or may not be functional, but which is at least relevant to the sensory environment in which we live. The economics of building has led to an area of aridity in our experience which is not consistent with the richness of our time.

An artist is a researcher into the potential impacts of media, taking meaning, for the moment, simply as another medium, in order not to rule out the value of abstract, pure art. He structures his perceptions as he finds them, and bases his work less on the categorical imperative than on a general sense of "Here this is, what is it? What can we do with it, if anything?" His milieu may be social, political, formal, perceptual, any combination of these and of other similar values as well. It is the lack of this element of art as aesthetic research which makes architecture so tedious today, with its endless cubes, conchoid curves, volumes and static relationships.

What better place to turn, initially, if one wishes to restore a spirit of aesthetic research to architecture, than to artists? That is the reason for doing this book.

Naturally there are very few practicing architects included. But there are works which take unorthodox approaches to the design of environment and space in ways which the architect must learn to use if the profession is not to disappear altogether in favor of a new beginning with utterly primitive artisanship and non-architecture. Some works here are process architecture. Some raise the question of durable versus temporary space. Some deal with the problem of consistency – which most recent architecture assumes is valuable in a work. Others deal with the expansion of the possibilities, plain and simple, into additional areas of technology and function. Some are fantasies, raising questions in the mind of the reader which hopefully will lead to new approaches towards design away from the drawing board. And perhaps these last are the most important body of work in this book, whose purpose is to answer nothing but to raise the most provocative questions.

<div style="text-align: right">

Dick Higgins
Barton, Vermont
June 28th, 1969

</div>

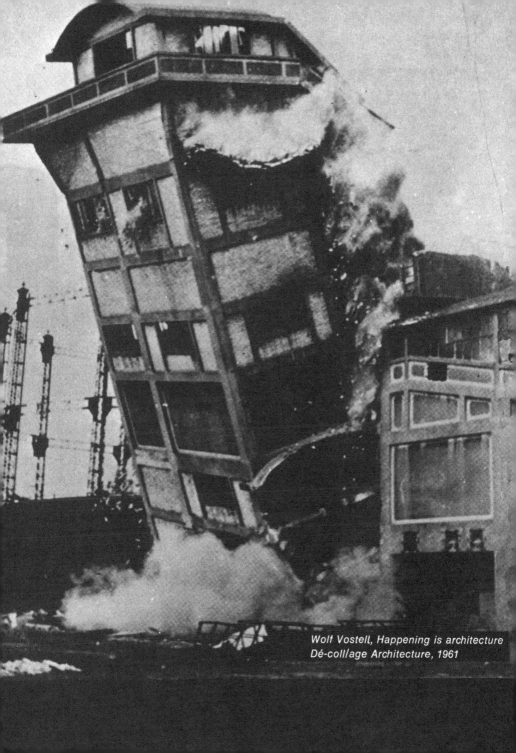

Wolf Vostell, Happening is architecture
Dé-coll/age Architecture, 1961

Gerhard Rühm, Plan for building a new city of Vienna, 1968

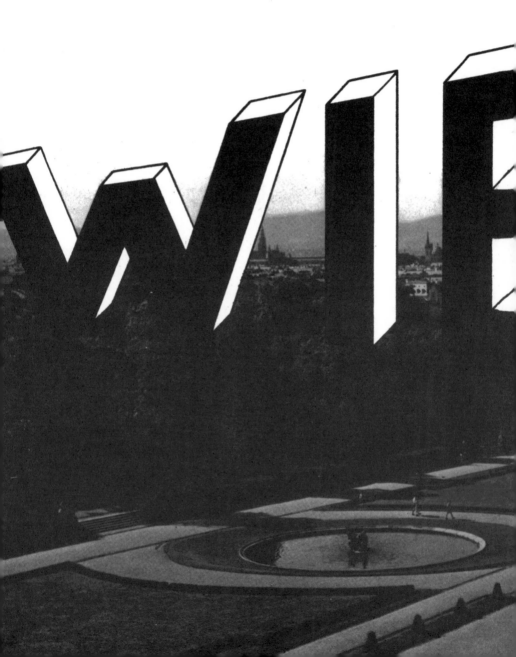

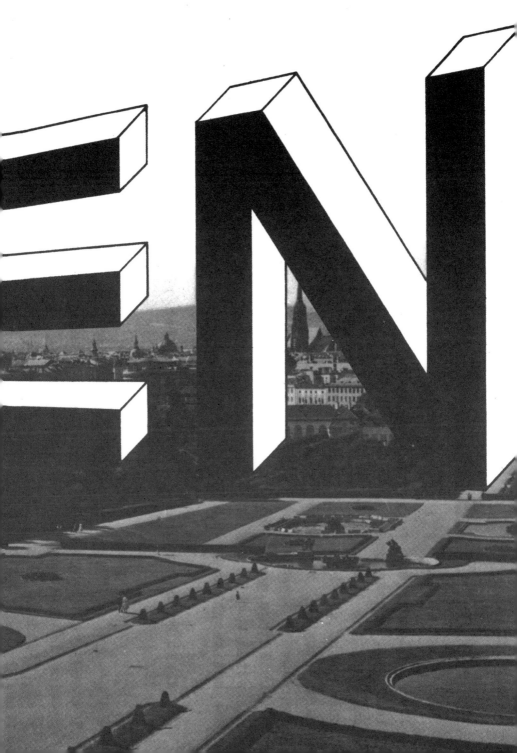

gerhard rühm

WIEN: plan for building a new city of Vienna

four buildings are to be constructed, the first in the shape of the letter W, the second in the shape of the letter I, the third in the shape of the letter E, and the fourth in the shape of the letter N. the height of these buildings is the same as vienna's cathedral of saint stephen, the diameter of the cubic columns and corridors is the same as that of the cathedral tower -- at approximately mid-height. the buildings are completely sealed off from the outside, and are connected with one another only underground, so that the inhabitants are not troubled by having to go out into the light of day.

the first building houses the city administration with its vast number of officials.

the second building serves for meditation. in muted tones from loud-speakers come in random succession but uninterruptedly all possible combinations of the letters w, i, e, and n, for example wie (how), wien (vienna), wein (wine), nie (never), wen (whom), or with repeated letters as in wenn (when), weinen (ween), nennen (name), if senseless

correct foreign pronunciation, e.g. new, for after all, vienna is supposed to be a cosmopolitan city.

in the third building the sex life of the inhabitants takes place. the lowest horizontal passage is for heterosexual partners, the middle one for homosexuals and lesbians, and the uppermost for onanists, who will be given the use of bugging devices for listening to the acoustic action of the lower corridors. naturally the compartmentalization may follow different and manifold lines, e.g. torture chambers for masochists, etc. etc. since new generations are undesired, there is no need for delivery rooms, nurseries and the like.

in the first column of the fourth building old people and invalids wait for death. to help while away the time the music of wine gardens resounds from above. when people expire, a device sucks them up to the top of the column and they slide down the slanting passage -- which extends sufficiently deep into the earth; ideally the fourth building should lie over a river to carry the corpses away rapidly. from black cowls hanging from the top of the second column, crosses could fall after them.

(1968)

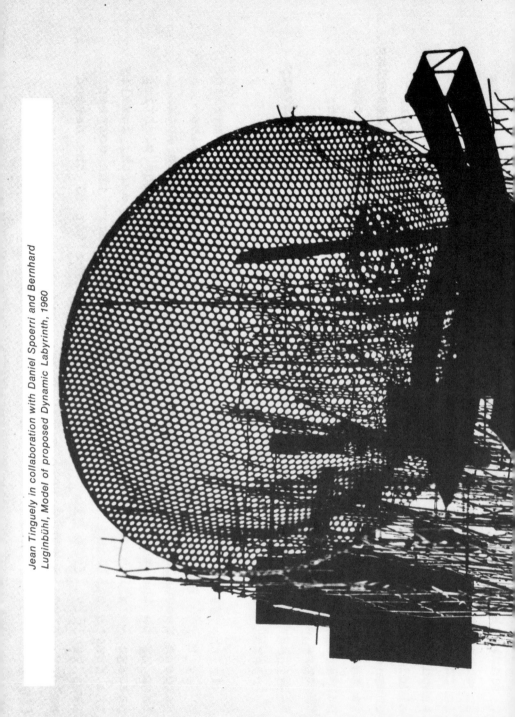

Jean Tinguely in collaboration with Daniel Spoerri and Bernhard Luginbühl, Model of proposed Dynamic Labyrinth, 1960

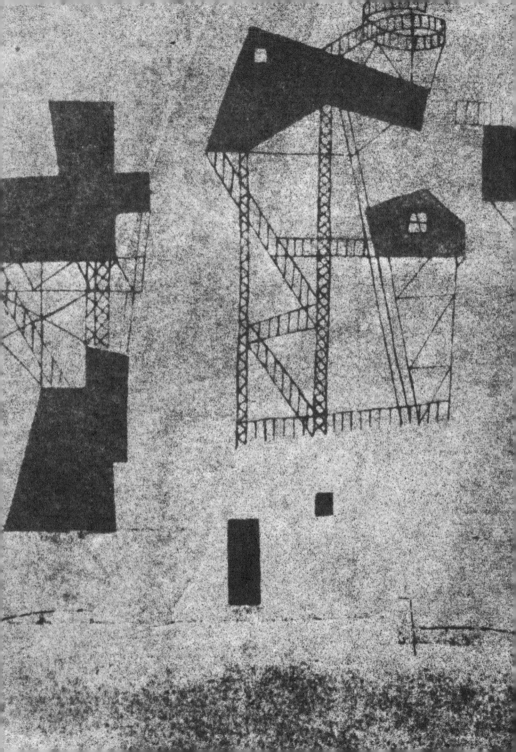

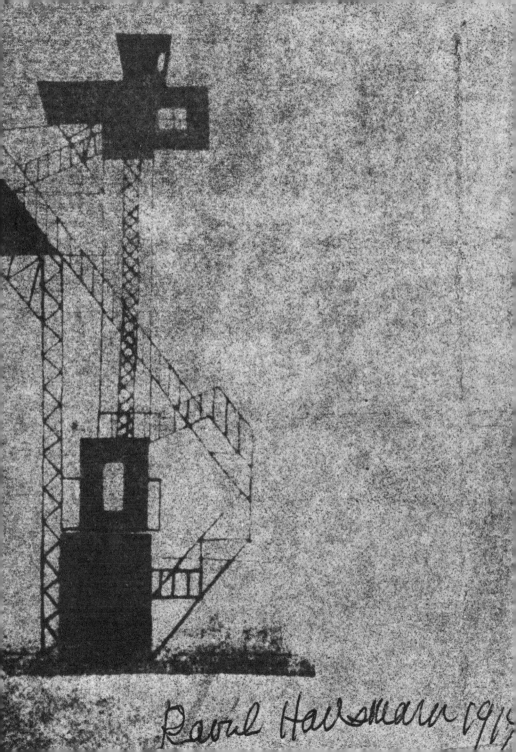

Raoul Hausmann 1919

Claes Oldenburg, Wing-Nut Monument
for Stockholm, 1966

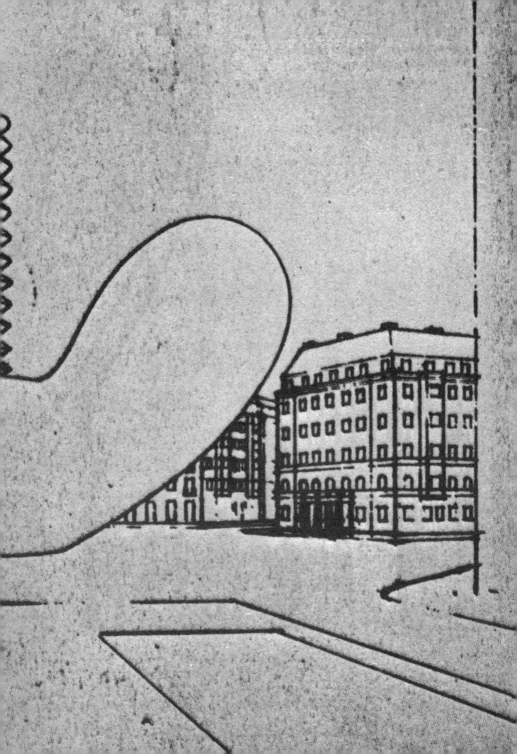

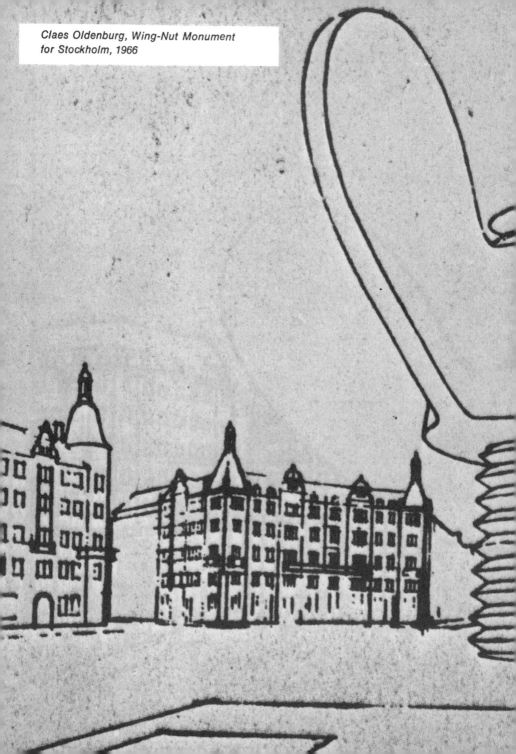

Claes Oldenburg, Wing-Nut Monument
for Stockholm, 1966

CAPTION 1

Architecture – to plan, to build, to move in space, to put together. To involve oneself in space, outside the earth, within it, or in the proportions within ourselves. The architecture of a body, or of a vegetable garden, or of a warehouse for shoes (in which the shoes must remain accessible, but the warehouse must not become full too quickly): to conserve space, or to activate it. Discovering the relationship between the space of a huge performance piece and the flow of traffic in a shopping center. Proposition: a highway system with all flow one way, converging on a point. Ridiculous? Think of rush hour traffic in a large city any morning. We have it. Reversed in the afternoon. What are the implications?

Space and scale – on the pages around this text, is Oldenburg's space the same when the screw is up as when it is down? Is anyone likely to be crushed under the screw as it descends? What concepts is he raising? Granted that the square looks very much like Stockholm, is it the screw that is large, or the city that is small? Is he saying something about the people of Stockholm or of any city? A few pages back, Raoul Hausmann. Why propose stairs leading nowhere? For whom might such a structure serve a purpose? For dictators looking for podiums? For gardeners looking for trellises for their roses to grow on? For stage directors trying to separate their actors onto different visual levels? Or does the image of the building say something about our time, about hierarchies and classifications? How large should it be to serve its purpose? And looking a few pages further, to Geoffrey Hendricks's clouds, which are the real clouds, and which did he compose with paint? How large must either be to create the disturbing illusion of the picture? From how far is the picture best viewed?

Architecture – to plan, to build, to move in space, to put together. To involve oneself in space, outside the earth, within it, or in the proportions within ourselves. The architecture of a body, or of a vegetable garden, or of a warehouse for shoes (in which the shoes must remain accessible, but the warehouse must not become full too quickly): to conserve space, or to activate it. Discovering the relationship between the space of a huge performance piece and the flow of traffic in a shopping center. Proposition: a highway system with all flow one way, converging on a point. Ridiculous? Think of rush hour traffic in a large city any morning. We have it. Reversed in the afternoon. What are the implications?

Space and scale – on the pages around this text, is Oldenburg's space the same when the screw is up as when it is down? Is anyone likely to be crushed under the screw as it descends? What concepts is he raising? Granted that the square looks very much like the Stockholm, is it the screw that is large, or the city that is small? Is he saying something about the people of Stockholm or of any city? A few pages back, Raoul Hausmann. Why propose stairs leading nowhere? For whom might such a structure serve a purpose? For dictators looking for podiums? For gardeners looking for trellisses for their roses to grow on? For stage directors trying to separate their actors onto different visual levels? Or does the image of the building say something about our time, about hierarchies and classifications? How large should it be to serve its purpose? And looking a few pages further, to Geoffrey Hendricke's clouds, which are the real clouds, and which did he compose with paint? How large must either be to create the disturbing illusion of the picture? From how far is the picture best viewed?

CAPTION 2

Change, renewal, metamorphosis – the seventy-eight functions each room of an old house has served over the years. The cities, once walled for protection, now looking for new invading armies of workers to take away and send home money from the cities. Some old places, needing a renewal of the spirit more than of the body, due so often to obsolescent practices being overprevalent. Others asking only that the body be cleaned and not ignored. But most often, to transpose, to mix without ever blending. The old window by Wewerka, sometimes right side up, sometimes upside down. Transposition. Very realistic, like a well planned manifesto, though it cannot exist in the real world. Is Wewerka the only practicing professional architect in this book? Or is Buckminster Fuller? Or is someone else? And if so, why? What is renewal? Who experiences it?

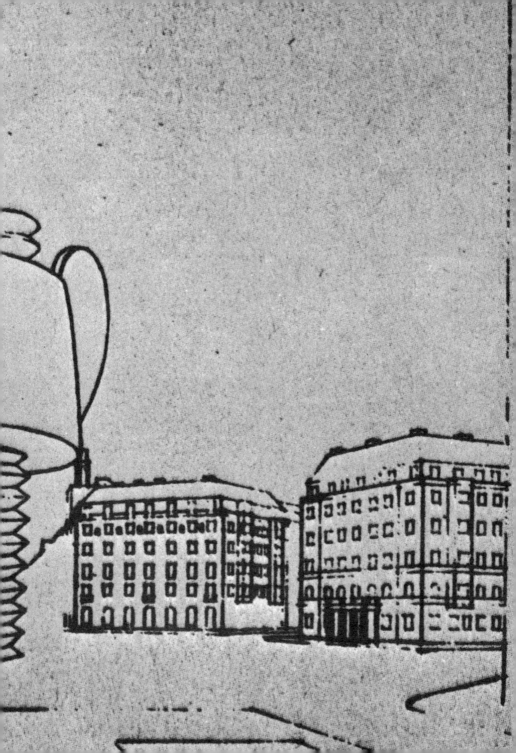

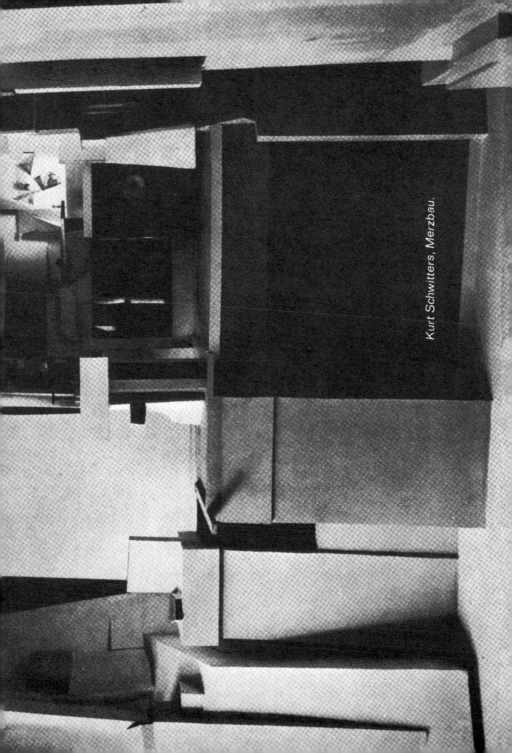

Kurt Schwitters, Merzbau.

Erich Buchholz, Architectural Sculpture, 1924

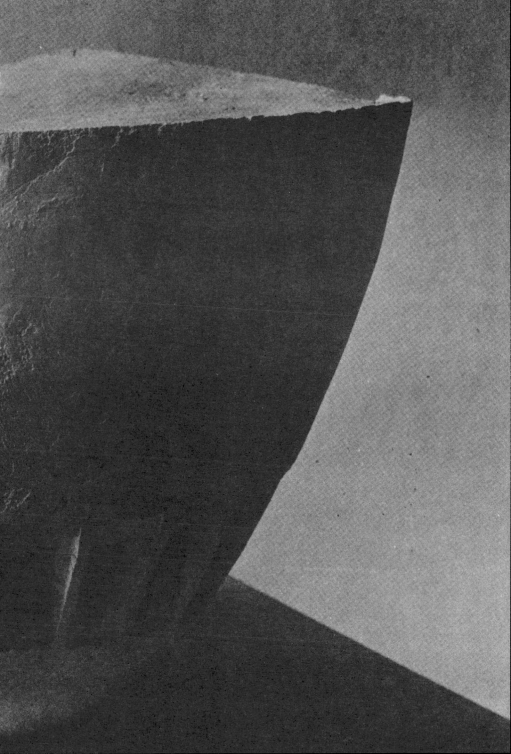

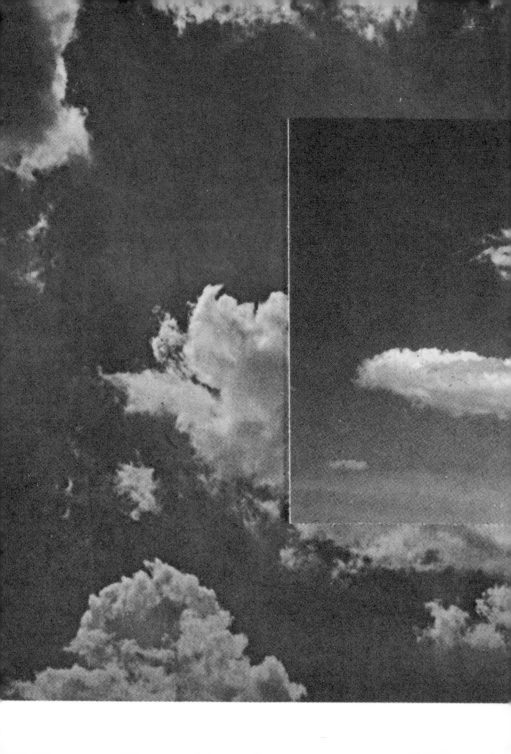

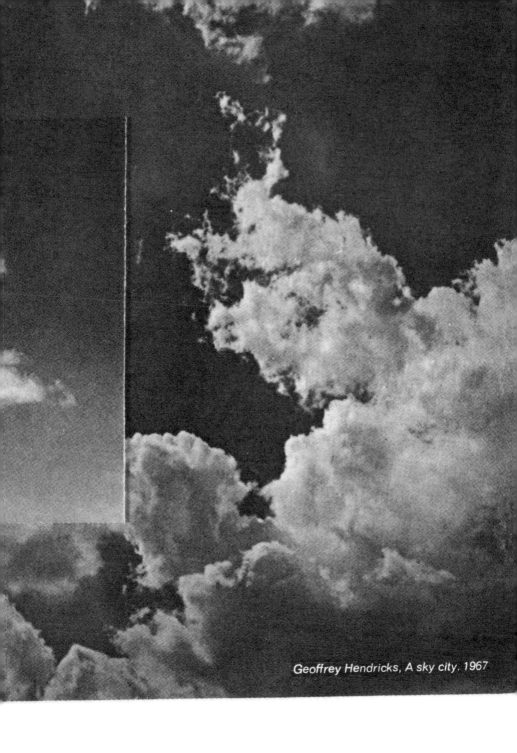

Geoffrey Hendricks, A sky city. 1967

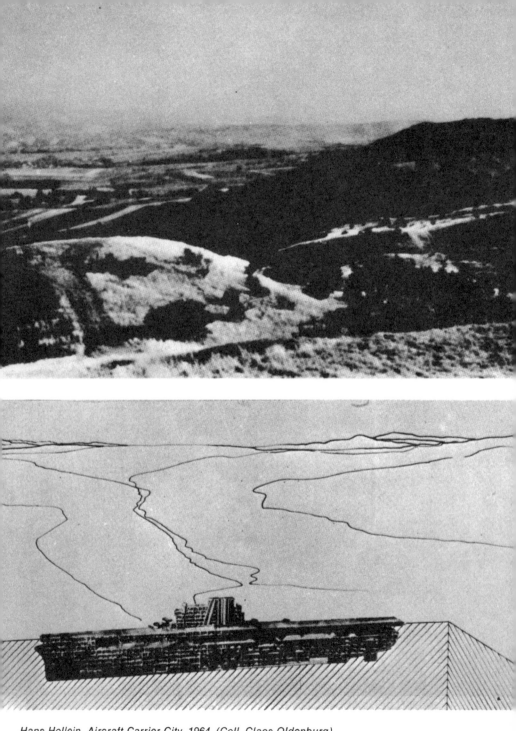

Hans Hollein, Aircraft Carrier City, 1964. (Coll. Claes Oldenburg)

Technology – to apply successfully one's material knowledge to any given problem. Simply to use complex techniques? Heck, half the time, what a waste. Artists and builders mostly using electron microscopes as fly swatters and computers as adding machines.

In the early 19th century the technology of steam was well known and had been for a hundred years, but it was only after this very long time lag that such men as Morey and Fulton "bothered" to make a steamboat. We cannot afford the luxury of such a time lag today. There are too many of us competing for space and for the world's material resources. If the "global village" idea seems trite and simplistic, at least the hard-to-name concept of violently interacting centrifugal and centripetal spirals is not, from a multiplicity of centers of activity and covering the earth. "The elephant and the Romanian question." "Burmese influences on the fishing industry of Helgoland." Hunger, and not just for food, as a common point from New York to Tsing-Hao, together with the new knowledge that this need not be.

The role of planners for the future such as Doxiadis, McHale and, above all, Buckminster Fuller becomes critical at this point, perhaps taking on the importance that the inventor had to the 19th century. First to take an inventory, then to develop what is needed. Fuller has compiled the most exhaustive inventory ever of raw information. He has inventoried "what is there" in the sense of people, raw manufacturing material, water power, human resources,

Technology – to apply successfully one's material knowledge to any given problem. Simply to use complex techniques? Heck, half the time, what a waste. Artists and builders mostly using electron microscopes as fly swatters and computers as adding machines.

In the early 19th century the technology of steam was well known and had been for a hundred years, but it was only after this very long time lag that such men as Morey and Fulton "bothered" to make a steamboat. We cannot afford the luxury of such a time lag today. There are too many of us competing for space and for the world's material resources. If the "global village" idea seems trite and simplistic, at least the hard-to-name concept of violently interacting centrifugal and centripetal spirals is not, from a multiplicity of centers of activity and covering the earth. "The elephant and the Romanian question." "Burmese influences on the fishing industry of Helgoland." Hunger, and not just for food, as a common point from New York to Tsing-Hao, together with the new knowledge that this need not be.

The role of planners for the future such as Doxiadis, McHale and, above all, Buckminster Fuller becomes critical at this point, perhaps taking on the importance that the inventor had to the 19th century. First to take an inventory, then to develop what is needed. Fuller has compiled the most exhaustive inventory ever of raw information. He has inventoried "what is there," in the sense of people, raw manufacturing material, water power, human resources,

etc., as well as techniques. He has even taken inventory of his own ideas. And added to other parts of the information, in other fields, primarily to complex geometry (his book on the subject is due to be published shortly). And then he has developed pilot projects, such as Triton City, simply by recognizing needs, checking the inventory of known techniques, and matching costs and resources against each other. Cities need space — space is available over the water, and, given proper waste disposal systems, need not interfere negatively with the ecology. Shipyards need work, especially now that so much travel is by air — so if shipyards can build ocean liners for 3500 people, why not solid, floating communities for 5000?

Can we dismiss this as mere material technocracy? Or do we do so at our own risk? Would the most conservative American pharmaceutical maker refuse to synthesize insulin simply because the techniques of doing so were developed in the Peoples' Republic of China? Do the problems with technocracy lie in the techniques and their assumptions? Or in their applications and the questions of communication connected with these? Ought we to criticize Fuller for his attempt to minimize the role of politics in his information flow? Or ought he perhaps be viewed heroically in the East as well as in the West, for his contributions to his fields? If the Encyclopedists of the 18th century had had Fuller's approach and some of his communications resources, would the steamboat have been invented any sooner?

etc., as well as techniques. He has even taken inventory of his own ideas. And added to
other parts of the information, in other fields, primarily to complex geometry (his book on the
subject is due to be published shortly). And then he has developed pilot projects, such as
Triton City, simply by recognizing needs, checking the inventory of known techniques, and
matching costs and resources against each other. Cities need space – space is available
over the water, and, given proper waste disposal systems, need not interfere negatively with
the ecology. Shipyards need work, especially now that so much travel is by air – so if
shipyards can build ocean liners for 3500 people, why not solid, floating communities for
3500?

Can we dismiss this as mere material technocracy? Or do we do so at our own risk? Would
the most conservative American pharmaceutical maker refuse to synthesize insulin simply
because the techniques of doing so were developed in the People's, Republic of China? Do
the problems with technocracy lie in the techniques and their assumptions? Or in their
applications and the questions of communications connected with these? Ought we to criticize
Fuller for his attempt to minimize the role of politics in his information flow? Or ought he
perhaps be viewed heroically in the East as well as in the West, for his contributions to his
fields? If the Encyclopedists of the 18th century had had Fuller's approach and some of his
communications resources, would the steamboat have been invented any sooner?

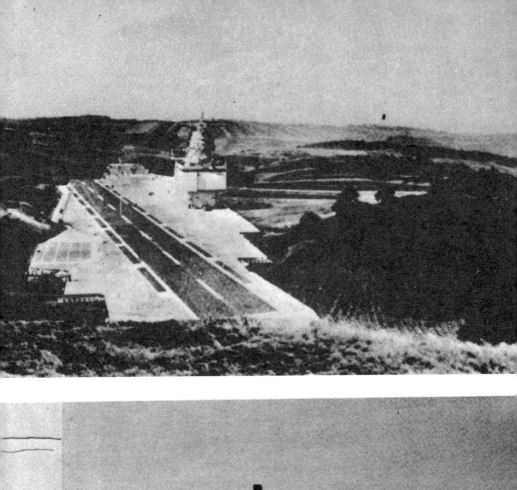

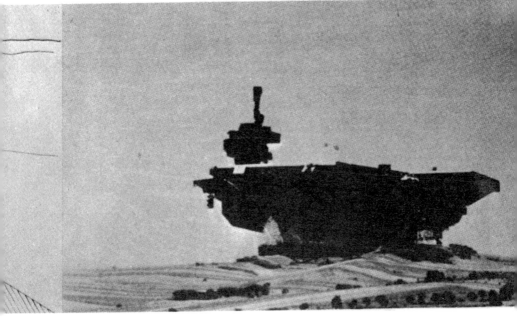

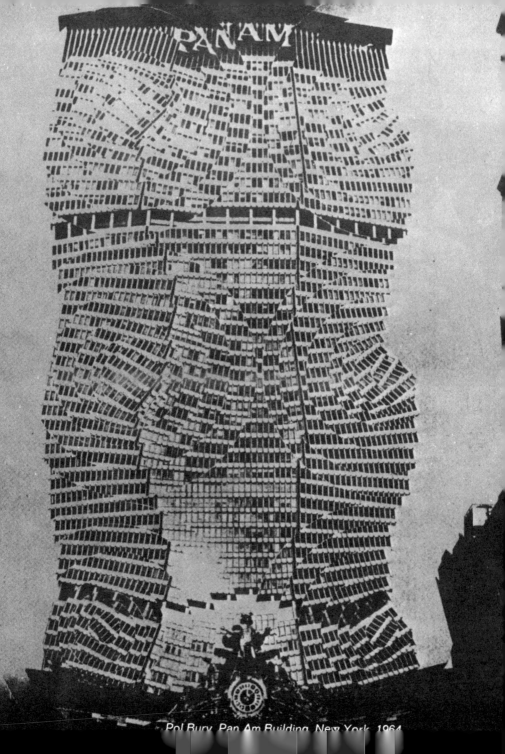

Pol Bury, Pan Am Building, New York, 1964

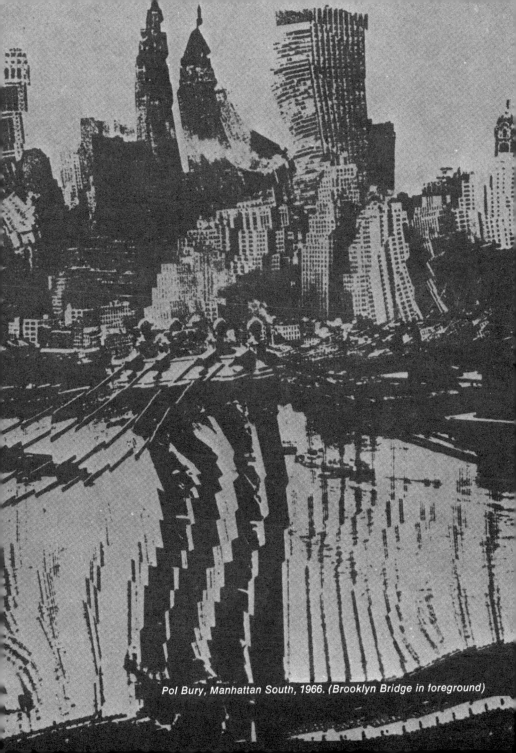

Pol Bury, Manhattan South, 1966. (Brooklyn Bridge in foreground)

Unfortunately this will remain a project. Cut
the earth in half, turn both halves in opposite
directions and glue them together again. Accra
would then be a suburb of London and the Niger
would flow into the North Sea and it would be
damn hot in London, or, vice versa, cold in Ac-

cra, it's hard to predict which. The rest of
the western part of the British Isles would be
located near the North Pole and the English
would be even frostier and Paris would lie close
to the Equator and in fact everything would be
totally different. Wewerka

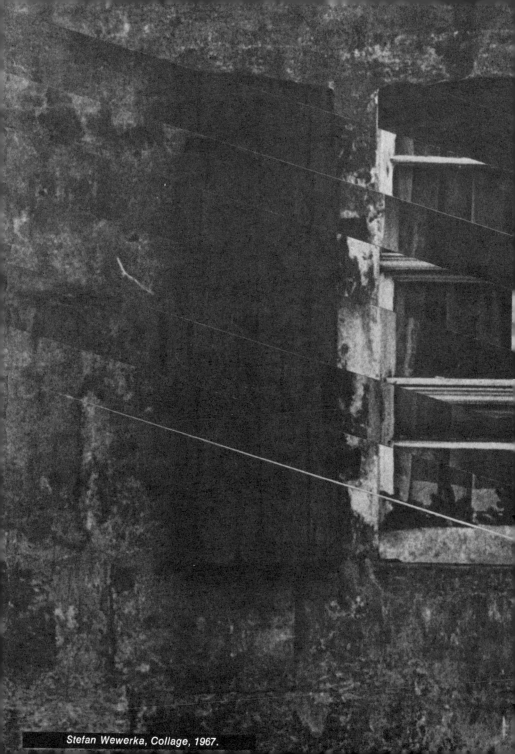

Stefan Wewerka, Collage, 1967.

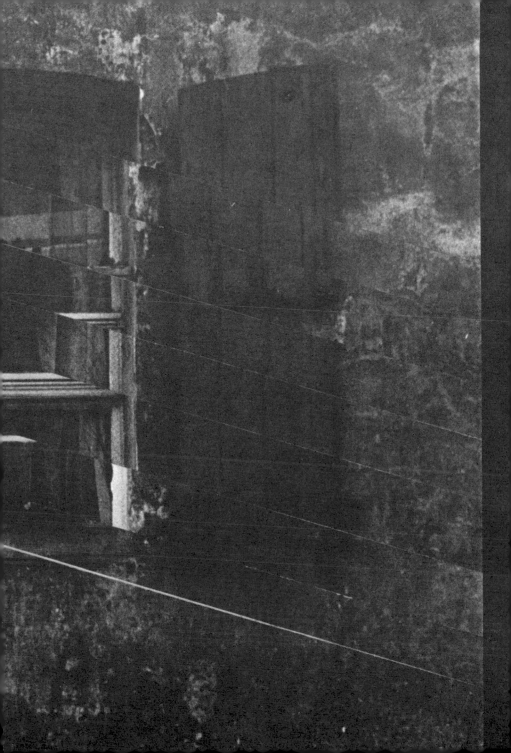

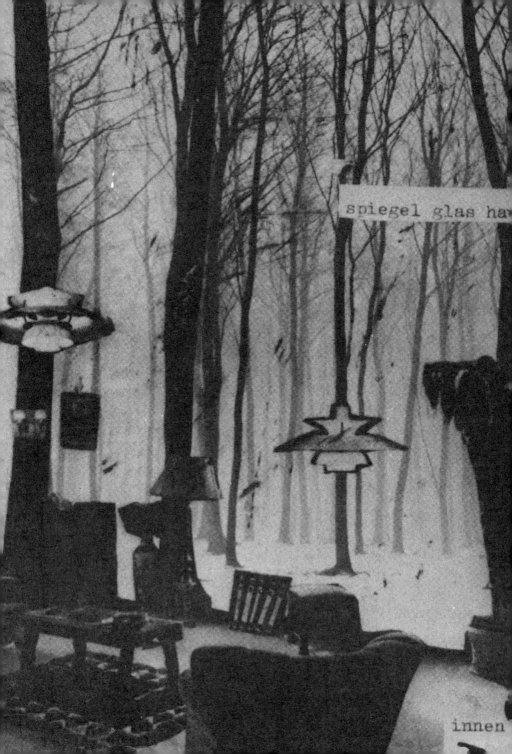

spiegel glas ha

innen

CAPTION 4

Architecture, art and non-art – a sculpture sat on? A chair. A chair understood as sculpture? A sculpture. Art is as art does. To the workman, building Oldenburg toilet floats on the Thames would be a job no different from building a bridge, a little more exotic maybe, but along the lines of industrial display perhaps. Looking back towards the beginning of this book, to the project of Tinguely, Spoerri and Luginbühl, might a workman be appalled by the inefficiency of the structure? Or might he be amused at the obvious waste of effort? And of the Schwitters M e r z b a u, can we ask if there is a non-art dimension to the work to anchor it? Or is its strongest statement its affirmation of some pure kind of aestheticism, rather foreign to us? Is the M e r z b a u as an ideal any more or less successful than the hypo-functionalism of a Luigi Nervi, with its adoration of the practical and the well engineered, and its high heating cost?

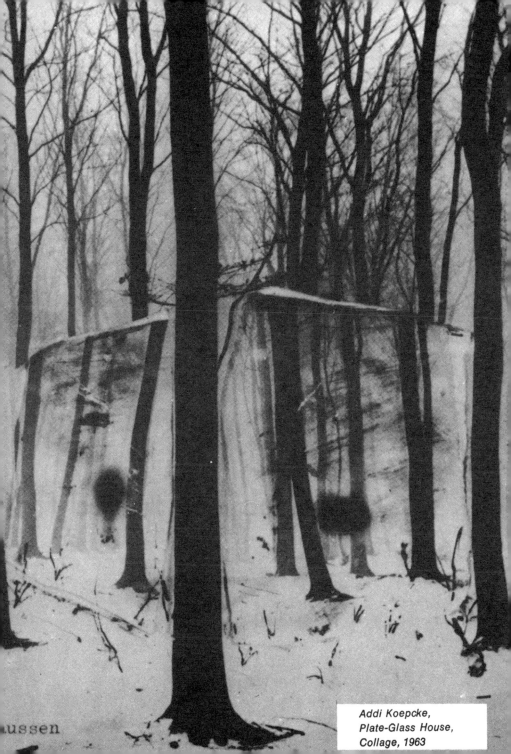

ussen

Addi Koepcke,
Plate-Glass House,
Collage, 1963

LAWRENCE WEINER

An object tossed from

30

New York

one country to another.

*Wolf Vostell, Proposal for an addition to the
Museum des 20. Jahrhunderts in Berlin, 1968*

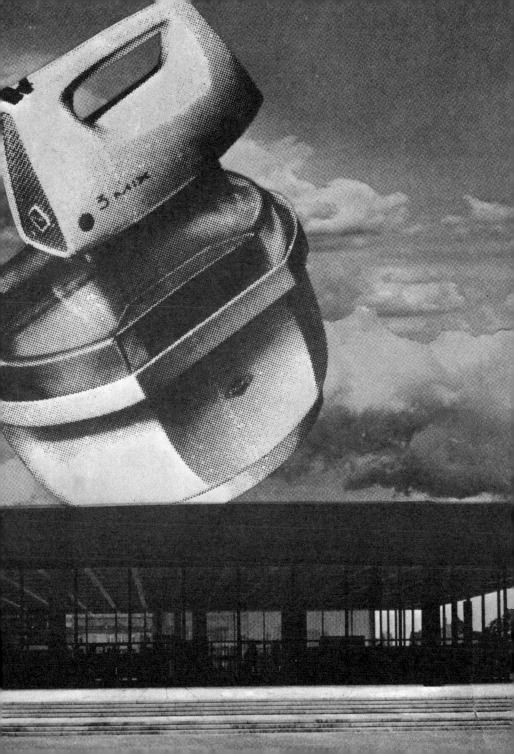

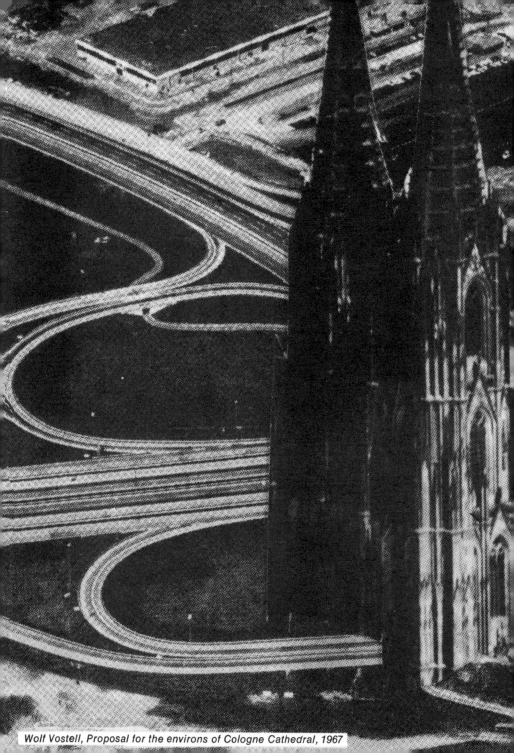

Wolf Vostell, Proposal for the environs of Cologne Cathedral, 1967

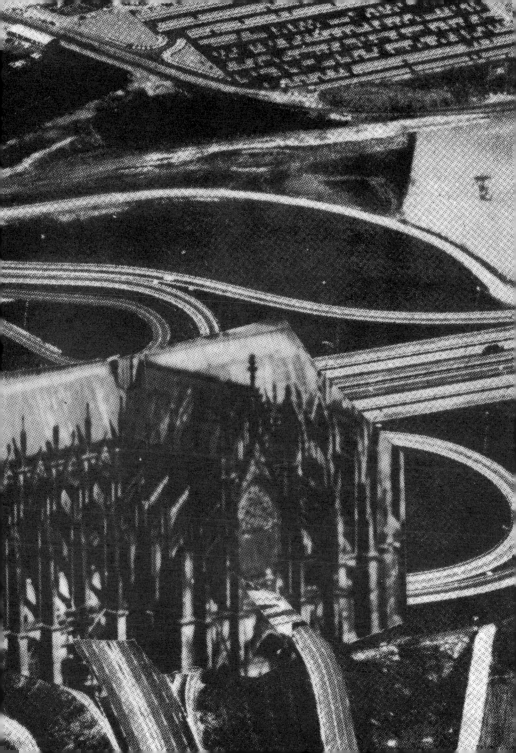

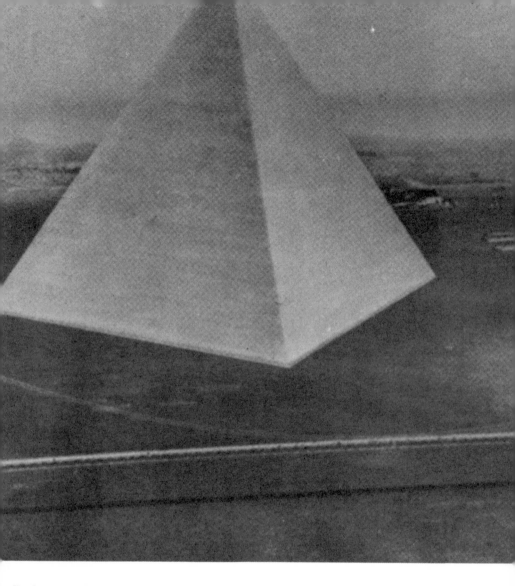

Buckminster Fuller, Tetra City, 1969

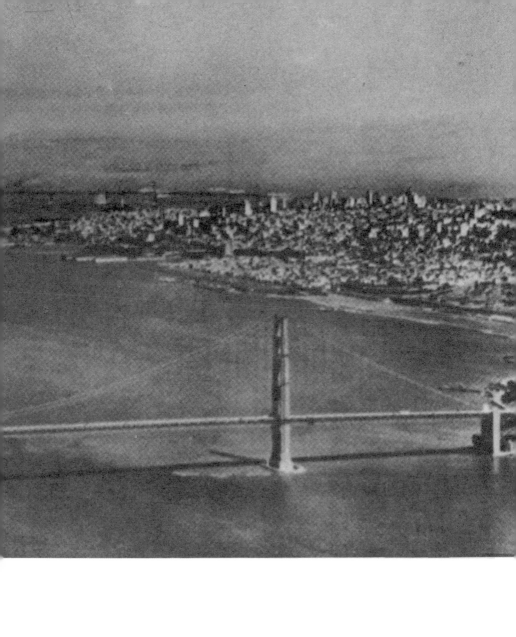

19. July 1964 :

Benuja empfiehlt Erhöhung
(bessere Proportion!)

der Berliner Mauer um 5 cm

"Beuys recommends raising the height of the Berlin Wall by
5 cm (better proportion!)"

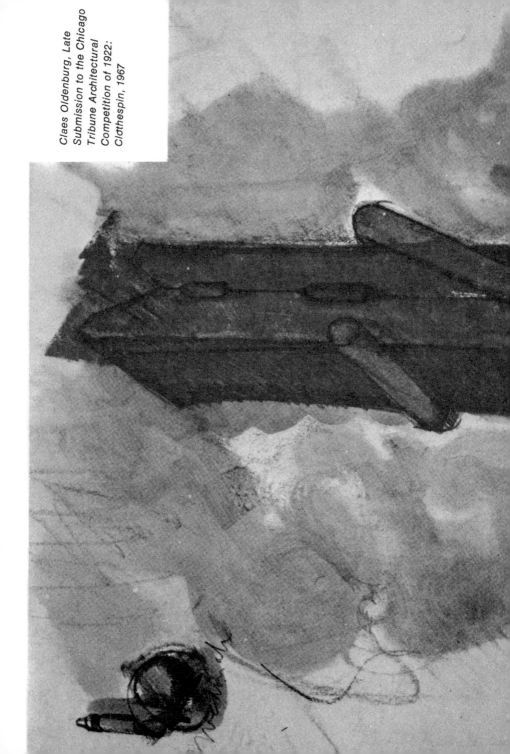

Claes Oldenburg, Late Submission to the Chicago Tribune Architectural Competition of 1922: Clothespin, 1967

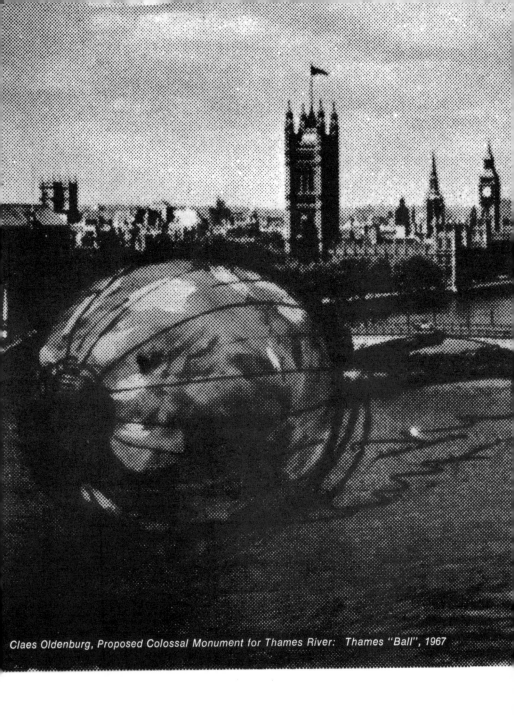

Claes Oldenburg, Proposed Colossal Monument for Thames River: Thames "Ball", 1967

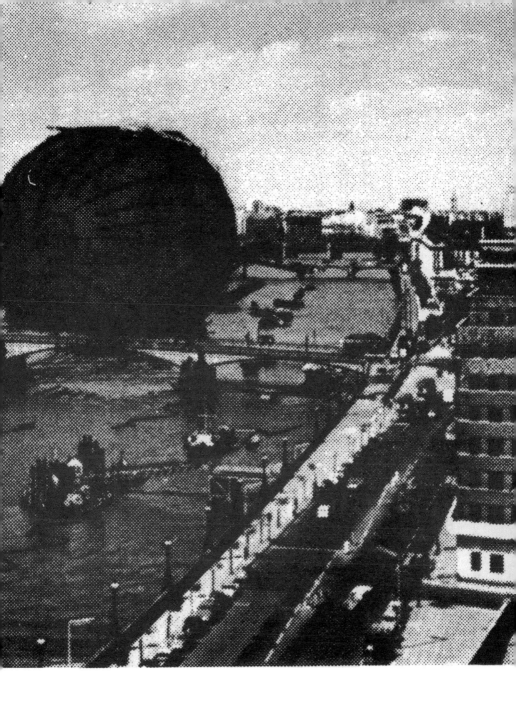

Carolee Schneemann

PARTS OF A BODY HOUSE

Entrance and Exit: The Coat Room

Admission to the Parts Of A Body House requires only that everyone bring a coat. The coat is hung up on any one of a series of infinite coat racks. On leaving everyone picks up and takes away a coat of their choice which is <u>not</u> the one they brought.

Cat House

When you enter the Body House you walk south and north for a long time; you come to an open circular structure -- a staircase of ribs, smooth and shiny white. You will see a fat knotted rope of black hair hanging down. The circular space has become dark. Take off your clothes, leave them. Hoist yourself up the rope; the hairs spread out and become a carpet you crawl along. It has led you into the Cat House which is somewhere behind the eyes of the house

CAPTION 5

Ecology – to participate in the body. A relationship, perhaps, between the body politic and the body physical? Between the body politic and any very large body of beings or of water or earth or air?

A lost element of ecology in the making of structures: to use local, found materials simply because they are there, usable, and natural, and to let them determine one's aesthetic, rather than to use them because one believes in it.

Can we go further? Should not all future architects and environmental scientists be required to study Urology, not just in the narrow sense of the gastric tract, but in the larger sense of the movement of all liquids and liquid-behaving solids and masses within our bodies? Are these not working models for the flow of all kinds of traffic? Concentrations of people and social engagements? Flows of information and social change? It is a system which, we know, works, where few of our social systems have been successful beyond the fairly limited goal of assuring their own survival, and have contributed little to whatever came afterwards.

Can we use our study of Urology in our environment and still remain good Marxists? Or Catholics? Or Scientologists? Or Conservatives? Or Neo-Leibnitzians? Or Mothers? To what seventeen bodies might each of us belong?

Ecology – to participate in the body. A relationship, perhaps, between the body politic and the body physical? Between the body politic and any very large body of water or of beings or of earth or air?

A lost element of ecology in the making of structures: to use local, found materials simply because they are there, usable, and natural, and to let them determine one's aesthetic, rather than to use them because one believed in it.

Can we go further? Should not all future architects and environmental scientists be required to study Urology, not just in the narrow sense of the gastric tract, but in the larger sense of the movement of all liquids and liquid-braving solids and masses within our bodies? Are these not working models for the flow of all kinds of traffic? Concentrations of people and social engagements? Flows of information and social change? It is a system which, we know, works, where very few of our social systems have been successful beyond the fairly limited goal of assuring their own survival, and have contributed little to whatever came afterwards.

Can we use our study of Urology in our environment and still remain good Marxists? Or Catholics? Or Scientologists? Or Conservatives? Or Neo-Leibnitzians? Or Mothers? To what seventeen bodies might each of us belong?

Cat House is a tiny room filled entirely with cats. They have their
own small door and enter and exit at will. Lie down among cats cats
kiss stroke brush walk sleep turn gently up and down your body
some cats knead your hair your belly they sniff your chin your
ears your thigh your armpits your sex dozens of furry shapes dif-
ferent weights textures walk on you move around you brush against
you lick you cats eyes shift shine blink off blink on cats purr hum
vibrate there is a tail against your neck lights of cats eyes flashing

Bathroom

When you leave the Cat House you enter a Bathroom, it is at the back
of the head of Body House.

1. stormy afternoon. A cat is swimming in the bathtub. In the bottom
of the bathtub is a large, crumpled burnt oil painting of nudes. The
cat soaks and swims a long time. You sit on the toilet watching. Some—

thing must be let in from the storm. You go and get chairs and pile them into the bathroom. You will have to stand in the bathtub to load them all up. Crawl in and out of chairs, piling chairs until they reach the ceiling. Stand in the tub among the chairs. Pick up the wet cat and dance blue raining blue light.

2. winter night. Get into the bathtub -- which is full of warm water and pine bubbles -- with someone you love. Make love in the water. The only light is blue-black night, gold and blue flashes. A cat comes to swim in the tub. It paddles and sneezes, it is fur-soaked. Then the cat sits on the edge of the tub watching you in the dark water. A film is made of this.

Lung Room

Walking south you will arrive at the Lung Room. Huge, transparent, glimmering lungs, seemingly suspended in air are stretched at varying

angles and levels through an endless space. You might best traverse these net-like lungs on hands and knees, crawling over the stretched membrane. In the center of a lung you can do jumps and falls, using it like a trampoline. Many people are crawling around; others have curled up, fallen asleep on the lungs; others are holding hands, bouncing through space from one lung to another. The transparent lungs are luminous; there is no other light to define space.

Heart Chamber / Cunt Chamber

A leap in the dark from an easterly lung: falling briefly, a sudden landing in the Heart Chamber / Cunt Chamber. Enormous soft velvety warm damp walls rounded ridged pulse gently. Your whole body is squeezed up and down; between pulses you can clamber around holding onto the ridges. Each ridge you touch emits a flash of brilliant colored light. It is slippery, the muscle walls expand, contract, push you slightly up or down. You may doze in the strange rocking. Only one or two persons at a time in this chamber. When you wish, begin to crawl down, head first, pushing between contractions. Exit.

Ice Palace

You arrive in the Ice Palace and are handed ice skates. This is simply a great frozen internal pond where everyone skates. Good old-fashioned skating music echoes here. A stand sells hot dogs and coffee.

Liver Room

The exit from the Ice Palace is a short peristaltic journey: an esoph-
agus / intestine. Just room enough to stand upright, bracing yourself
with hands against the walls. You are quickly propelled forward. An
almost unbearable foul aroma. No light at all. You will be ejected
either into the Liver Room or Nerve Ends Room.

The Liver Room is sculptural: chunks of liver-like stuff (brown poly-
urethene), about twelve feet long each, are piled into an overlapping
hilly structure. Near rivulets picnic baskets and jugs have been em-
bedded under crevices. All your friends are here to picnic. There is
a pleasant glowing golden light, smell of the sea. People climb about
on the livers, which are nice and springy, they sit on outcroppings
and edges, sharing food and drink. At the top of the hills there is a
long narrow machine which when tapped will blow out a length of foamy
brown blanket. These blankets slowly dissolve and are left blowing
about. A certain amount of dancing, arguing, singing; and napping and
intimate love-sleep in more remote crevices.

The Nerve Ends Room

The Nerve Ends Room is evolved as a free-flowing, self-perpetuating, self-destroying energy environment using active elements of:

ORGASMIC STREAMING ORGANIC GARDENING ELECTROCULTURE BIRDS ACID
JOYFUL TECHNOLOGY EXTRASENSORY PERCEPTION WILD-LIFE PRESERVATION
LENNY BRUCE BLACK POWER BACH BEATLES BEAST SONG SYNESTHESIA
KINESTHESIA

Ecstatic physical interchange. Participants will freely choose music, noise, lights, seasons, stars, galaxies, winds, colors, photocell ac-tivations, circuits cut-offs, slides, film, laser beams, traffic sig-nals, dirt, sand, mud, grease, powder, friendly animals, fabrics, SCRs, water, fires...ropes, swings, ladders, smells, aromas, wood, nails, hammers, saws, chisels, trees, shrubs, flowers, costumes....and agree only that their choices may exist simultaneously in juxtaposition with the choices of others in the same time-space continuum.

The participants will be able to select their materials in advance; they may also build or activate parts of the environment with found

materials or by using preset electronic circuits — sensory components determined by computer programs. The found materials can be used in any imaginable way, alone or in cooperation with other people. Maximum sensory information and strange immediate physical circumstances will provoke actions / reactions in developing involvement. People will be bombarded, "charged", as they shape and reshape the environment. Ear plugs, eye masks, perfume, tiny lights and hunks of foam rubber to build chambers will be available to disperse environmental conflagrations — to provide utter quiet for private turnings-in / turnings-on. LSD, DMT, pot, alcoholic drinks, mushrooms, vitamins, strange and common foods will be available. The Nerve Ends Room will be situated in a transparent bubble in a woods to facilitate exchange of inside and outside, actual landscape and fantastic landscape.

Finally, a memory bank will be available to everyone by which they can open travel into their experiences to anyone desiring to go where they have been. (My memory-bank idea is fully described in the English magazine Icteric.)

The Kidney Room

In the Kidney Room people co... discuss revolution, that is, changing or tran...orming ...rms which are repressive, exploitative, divisiv... ...ve. It is a simple outdoor space (a vague sheltering land... daytime light; a luminescent green Bile River runs by. The... ree large kidneys to sit on, made of stone; they form a sem... e o. a grassy bank.

CAPTION 6

Monuments – to inspire with a structure, to awake a consciousness of something through this. A work, perhaps a saying or a deed, worthy of record or of enduring. A monument to endurance, or sometimes to folly. Why no monuments to the very ordinary?
A monument to the woman who discovered the use of fire? Why do we always refer to the first "man" who invented fire? Is it as the first of the species to do so? It is this lack of monuments to the ordinary which we are now, in our time, endeavoring to correct. In a New York park there is a monument over the grave of "Tim, a good boy". He died and was buried on land which later became a city park. About him nothing else is known.

Monuments – to inspire with a structure, to awake a consciousness of something this. A work, perhaps a saying or a deed, worthy of record or of enduring. A monument to endurance, or sometimes to folly. Why no monuments to the very ordinary? A monument to the woman who discovered the use of fire? Why do we always refer to the first "man" who invented fire? Is it as the first of the species to do so? It is this lack of monuments to the ordinary which we are now, in our time, endeavoring to correct. In a New York park there is a monument over the grave of "Tim, a good boy". He died and was buried on land which later became a city park. About him nothing else is known.

Whether or not they choose to admit it, many of the new artists, those who transform the earth for a moment only, are working in the tradition of monuments. To plow the land in order to prepare it for seeds, this is the perfectly normal model. To plow it for its own sake, to perhaps compose the seeding as an event, as Dennis Oppenheim has, this transforms it. Does it add meaning to the more routine kinds of seeding? What kinds of feedback exist? How long must a work exist to be permanent? How many people must observe it for it to be less than purely private? Is it pointless to name the functions of such a monumental construction?

Whether or not they choose to admit it, many of the new artists, those who transform the earth for a moment only, are working in the tradition of monuments. To plow the land in order to prepare it for seeds, this is the perfectly normal model. To plow it for its own sake, to perhaps compose the seeding as an event, as Dennis Oppenheim has, this transforms it. Does it add meaning to the more routine kinds of seeding? What kinds of feedback exist? How long must a work exist to be permanent? How many people must observe it for it to be less than purely private? Is it pointless to name the functions of such a monumental construction?

The Guerrilla Gut

On the opposite side of the Bile River is a long tract of jungle and
forest, in which four city blocks are situated, a military installa-
tion, and a harbor. This complex is called the Gut. In the Gut the
people gather to enact various guerrilla exercises which last from a
few hours to a few months. A basic guerrilla-life-theater which in-
cludes: living alone, living together confined, loving, arguing; how
to build and choose together, how to fulfill tasks, finding food and
water and their distribution, cooking without an open fire, sewing,
first aid; jumping, catapulting across obstacles, crawling for hours,
scaling walls, running, carrying and lifting bodies, hiking from one
place to another without directions in the night, in the day; climbing
trees, hide-and-seek, planting traps, sleeping under leaves, in mud
and sand, etc. In a continually improvised environment -- using found
materials -- basic skills in building will be tried; making traps,
simple explosives, rope knotting; blocking roads, buildings and the
harbor will be attempted. And within the Gut labyrinth the people
have reunions after separations, celebrations around fires, dancing

before difficult tasks, reading the stars, gardening, falling in love for moments or years. In an open field they may develop self-defense methods: camouflage, masks, disguises, pageantry....Non-verbal communications will be set up using fire and light signals, marks and signs made or found in the landscape, and communication by mutual body energy awareness. Special technical effects and certain physical relationships of people and materials will be monitored from the Nerve Ends Room and may be adapted to uses for the Gut.

The Genitals Play — Erotica Meat Room

In the center of the Body House. It may be chosen instead of the Guerrilla Gut Room.

A large, curving space filled entirely with wonderfully fashioned,

over-life-size pricks, balls, nipples, clitorises, labia majora, labia minora, cunts and ass holes. They will be lifelike in variations of detail, color, aroma and moisture; constructed from fleshlike materials, they completely cover floors, walls, ceiling. They are electrically charged and when handled properly they will undergo lifelike transformations and as they are touched they communicate to the toucher, flood the toucher with the most extreme sensations he or she could normally feel. The genitals-meat are disposed so that it is possible to climb on them, swing on them, ride, run and jump among them — all the time receiving an ecstatic electrical current. Being a putting on a taking off and opening and following a strange courtship a romance (not all forms of violence are destructive) foam forms for energy streams followed into movement moment take in color texture as physical necessity / immediacy: An Image. In your own time your own way with another no one can predict how this room will effect them how will they effect this room (let insights follow delight). A complex structure to be alone in one section crowded in another: noninterference cooperation new modes of reciprocal play love electrical pandemonium harmony wild encounters any manner.

Hair and Fingers Room

A resting place after the Nerve Ends Room or Genital Play - Erotica
Meat Room. An attic full of couches, chairs, big sofas made from
oversize soft finger shapes covered with webs, clumps of hair (dif-
ferent textures, colors, aromas); a tiny labyrinth where it is
always possible to lie down, beast sleep, curl up on fingers, cov-
ered with lengths of warm hair. Silent. A warm breeze. Always twilight.

J. J. Herman, This is my song, Collage. 1969

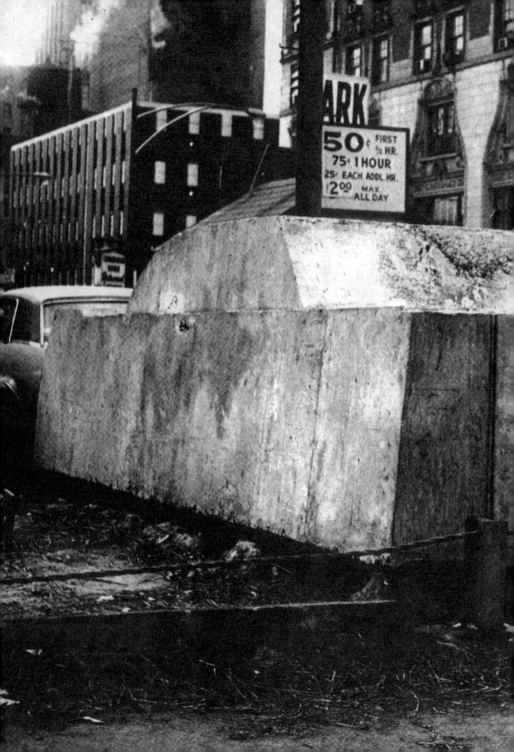

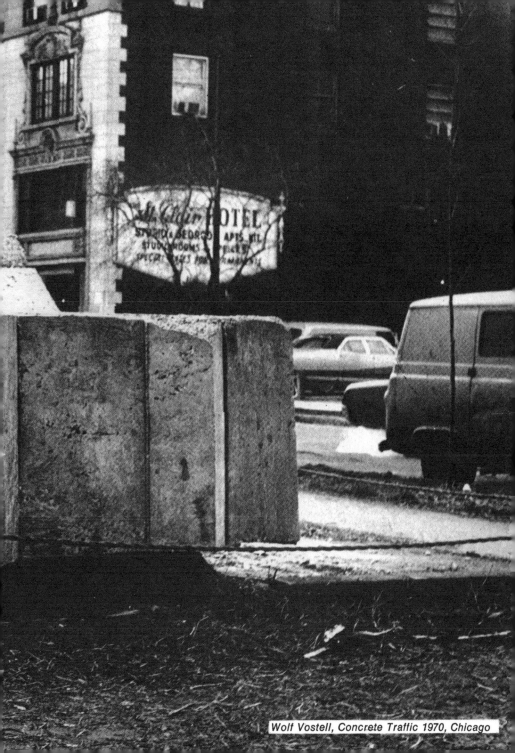

Wolf Vostell, Concrete Traffic 1970, Chicago

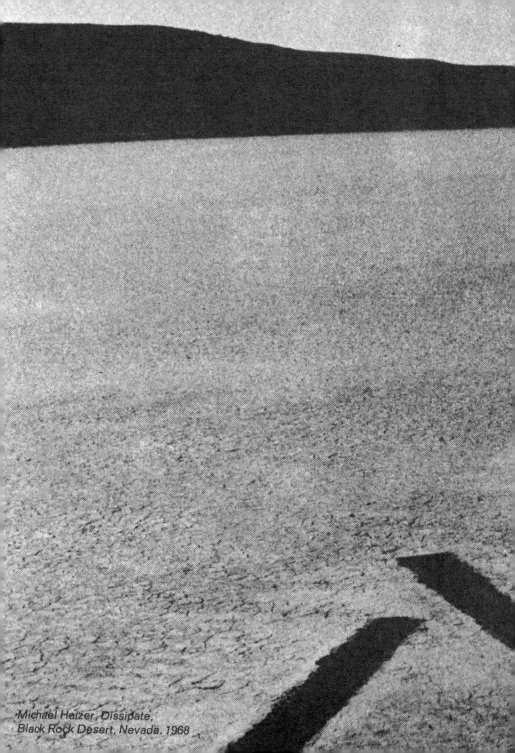

Michael Heizer, Dissipate,
Black Rock Desert, Nevada, 1968

CAPTION 7

Architecture as event – to collide with a wall that didn't used to be there. To watch a building being made, to experience its destruction, to remember where it was after it is removed. Buildings as the result of an act of building. This act unique in itself. Terrible traffic jams due to the slowness of highway construction. A family homeless, due to delay in construction but having to leave a previous residence, by contract. A workman being killed while building a ski chalet on a high cliff. The entire structure of a New York skyscraper on Park Avenue, put up and covered in 48 hours. Then too, the violent act of existing as a physical building. Statistics: In high winds, the top of the Empire State Building is said to swing back and forth over four meters, and the building is said to be more than a meter higher in hot weather than in cold, due to the expansion of its materials. Certain buildings, simply by existing, cut off our views of something else. Or their air-conditioning systems make noise, but cannot be turned off, and their existence becomes a musical element. Or they cause the earth to sink. Or they attract a great deal of traffic or people to an area. But most important, they cause an empty space to become an occupied one. Can one design buildings with this, as such, in mind? Are there new ways we can activate space and human functions by using this fact of occupancy as central, rather than endlessly concentrating on simple functions for buildings? Can we work where we sleep? Would this enrich our lives in any way?

Back at the very beginning of this book, did Gerhard Rühm pose or answer any of these questions in his proposals for a new city of Vienna? How about Hans Hollein in his Aircraft Carrier City? Would Hollein's proposal best be left as a metaphor, to imagine but not to do? Or does it maybe really offer enough solutions to basic problems (an ideal centralized water distribution for extremely arid wastes, or heat distribution for cold areas, if one wished to develop and exploit the minerals of the Moon or Antarctica) for the proposal to be taken very seriously in one or another context?

CAPTION 8

Good space, bad space – to be free to move, or to be cramped and confined. The good space of one time, the bad space of another. Cities designed for a world before automobiles or for later. The 19th century dream of domed cities, with free movement under skies protected from rain and weather. Today, even without automobiles permitted under the enclosure, to observe that the air would be abominable, and the people, far from becoming delighted by each others' body warmth and physical pleasure, in the mediterranean manner, would experience instead the sensation of communal discomfort, and would therefore behave to one another like travelers on an overcrowded commuter train. To observe all this, and that Hollywood, with its freeways and its low, spread-out buildings up and down the hills, is a 20th century city, while New York, Boston and so many of the European cities (Copenhagen an exception, for instance?) belong to an older era?

CAPTION 8

Good space, bad space – to be free to move, or to be cramped and confined. The good space of one time, the bad space of another. Cities designed for a world before automobile or for later. The 19th century dream of domed cities, with free movement under skies protected from rain and weather. Today, even without automobiles permitted under the enclosure, to observe that the air would be abominable, and the people, far from becoming delighted by each others' body warmth and physical pleasure, in the mediterranean manner, would experience instead the sensation of communal discomfort, and would therefore behave to one another like travelers on an overcrowded commuter train. To observe all this, and that Hollywood, with its freeways and its low, spread-out buildings up and down the hills, is a 20th century city, while New York, Boston and so many of the European cities (Copenhagen an exception, for instance?) belong to an older era?

Architectural Project #2

by Dick Higgins

is performed by

— starting with a circular loop of plastic tubing that is two or three adults' heights in diameter

— twisting the loop over to form a figure eight

- cutting a door where the loop crosses over itself so

 that one can walk on the loop

- cutting doors into the courtyards and outside

- wrapping the loop over and over with electrical

 wires and plumbing

- cutting as many windows as possible

- growing vines in the wires and the plumbing

December 23, 1966

NOTE-O-GRAM®
© THE DRAWING BOARD · BOX 505 · DALLAS, TEXAS
401 EDGEBROOK DRIVE APT. 303 · CHAMPAIGN, ILLINOIS 61820 · PHONE (217) 352-5961
JOHN CAGE

MESSAGE

TO: Dick Higgins
607½ W. University

Dick Higgins
238 West 22nd St.
New York, NY 10011

DATE: Nov. 20, 1968

Thank you for all the cards (Europe
& now US). When you get a
chance, let me know what
happened & what grew up to
Gab book plans (from small
one. McLuhan — Massie — etc) amazing
to see that the project actually
got finished. Though I'm not
in Missouri, I'll have to see
it to believe it. Am enslaved

REPLY

DATE:

now by another project — The
computer one enters 16th
month now!?!?! But I
have a beautiful apt. here
& wake up every morning
all eager to begin day.
Color fully Wriam gives me
idea for Preminiature book?
A house with walls E. & W.
filled with video recording
means so that one cd.
record sunrises + sunsets,
playing them back at a
later time, crossing means etc.

love, J.

BOSTON

Douglas Huebler

A HOUSE OF DUST

IN A PLACE WITH BOTH HEAVY RAIN AND BRIGHT SUN
 USING ALL AVAILABLE LIGHTING
 INHABITED BY FRIENDS

A HOUSE OF DUST
 IN A DESERTED CHURCH
 USING ALL AVAILABLE LIGHTING
 INHABITED BY PEOPLE SPEAKING MANY LANGUAGES WEARING LITTLE OR NO CLOTHING

A HOUSE OF MUD
 IN AN OVERPOPULATED AREA
 USING ELECTRICITY
 INHABITED BY LITTLE BOYS

A HOUSE OF WEEDS
 UNDERWATER
 USING CANDLES
 INHABITED BY VARIOUS BIRDS AND FISH

A HOUSE OF BROKEN DISHES
 IN SOUTHERN FRANCE
 USING CANDLES
 INHABITED BY PEOPLE WHO ENJOY EATING TOGETHER

A HOUSE OF ROOTS
 IN A PLACE WITH BOTH HEAVY RAIN AND BRIGHT SUN
 USING ALL AVAILABLE LIGHTING
 INHABITED BY PEOPLE WHO LOVE TO READ

A HOUSE OF STRAW
 IN SOUTHERN FRANCE
 USING NATURAL LIGHT
 INHABITED BY COLLECTORS OF ALL TYPES

A HOUSE OF STRAW
 IN MICHIGAN
 USING ALL AVAILABLE LIGHTING
 INHABITED BY VARIOUS BIRDS AND FISH

A HOUSE OF STEEL
 IN A METROPOLIS
 USING ELECTRICITY
 INHABITED BY FRIENDS AND ENEMIES

A HOUSE OF PAPER
 BY AN ABANDONED LAKE
 USING ALL AVAILABLE LIGHTING
 INHABITED BY FRIENDS

A HOUSE OF PLASTIC
 ON AN ISLAND
 USING ELECTRICITY
 INHABITED BY PEOPLE FROM MANY WALKS OF LIFE

A HOUSE OF ROOTS
 AMONG SMALL HILLS
 USING NATURAL LIGHT
 INHABITED BY AMERICAN INDIANS

A HOUSE OF DISCARDED CLOTHING
 IN A HOT CLIMATE
 USING ELECTRICITY
 INHABITED BY AMERICAN INDIANS

A HOUSE OF BRICK
 AMONG OTHER HOUSES
 USING ALL AVAILABLE LIGHTING
 INHABITED BY FRIENDS

A HOUSE OF LEAVES
 UNDERWATER
 USING CANDLES
 INHABITED BY COLLECTORS OF ALL TYPES

CAPTION 9

Verticality and cost – in 19th century cities, based on walking more than riding, to have many people together where land becomes costly. New York's skyscrapers as an archaism. The long lines of business executives in New York's Pan Am Building (see Pol Bury's collage) waiting on the 23rd or the 75th floor for an elevator at lunch time, dictating letters to their secretaries as they wait. Eric Andersen (Copenhagen philosoph) admiring Corbusier and his blank-faced communities, and human modules, Vautier composing ideal parody, using material cost instead of human cost. Vostell mixing the monument of one time with the monument of another, in downtown Aachen, but protesting too against the verticality that is so obsolescent in our time.

Let the houses of the future be one or two miles high, but let them have roads, swinging out to the wind, at each level, so that they are not so much purely vertical but parallel on many levels. At least in good weather, what a pleasure to walk so high above the ground. To ride in cable cars from one industrial tower a mile above the ground to another a mile away. Sometimes passing another cable car above or below, reserved for freight. This would be a more humane verticality than this monstrous dependence on elevators, air conditioning and walking to lunch on the world's most expensive hamburger, priced simply according to the demand for it and a happy location beside a skyscraper.

Vertically and cost – in 19th century cities, based on walking more than riding, to have many people together where land becomes costly. New York's skyscrapers as an archaism. The long lines of business executives in New York's Pan Am Building (see Pol Bury's collage) waiting on the 23rd or the 75th floor for an elevator at lunch time, dictating letters to their secretaries as they wait. Eric Andersen (Copenhagen philosoph) admiring Corbusier and his blank-faced communities, and human modules, Vautier composing ideal parody, using material cost instead of human cost. Vostell mixing the monument of one time with the monument of another, in downtown Aachen, but protesting too against the verticality that is so obsolescent in our time.

Let the houses of the future be one or two miles high, but let them have roads, swinging out to the wind, at each level, so that they are not so much purely vertical but parallel on many levels. At least in good weather, what a pleasure to walk so high above the ground. To ride in cable cars from one industrial tower a mile above the ground to another a mile away. Sometimes passing another cable car above or below, reserved for freight. This would be a more humane verticality than this monstrous dependence on elevators, air conditioning and walking to lunch on the world's most expensive hamburger, priced simply according to the demand for it and a happy location beside a skyscraper.

CAPTION 10

Cost – to plan designs based on cost, simplicity, and the joy, not the ambition, of the project. Does Franz Mon's Labyrinth reflect this? Do Oldenburg's scissors reflect other things as well (besides the obvious, monumental aspect)? Where should Oldenburg's pool balls go? Towards what structures might they move? (Note: Broadway and Canal Street in New York was once described as the ideal spot for an atomic bomb to be dropped for maximum destruction. I used to live there, I told Claes that, and he did this.) In what ways does Hödike's revolving door break up this verticality? Does Raoul Hausmann's C a l l t o F a n t a s y sum up what I've been saying? Is he a mere Dadaist, or is Dada perhaps a sort of realism or more? And is it just a world of costs in which we live?

CAPTION 10

Cost – to plan designs based on cost, simplicity, and the joy, not the ambition, of the project. Does Franz Mon's Labyrinth reflect this? Do Oldenburg's scissors reflect other things as well (besides the obvious, monumental aspect)? Where should Oldenburg's pool balls go? Towards what structures might they move? (Note: Broadway and Canal Street in New York was once described as the ideal spot for an atomic bomb to be dropped for maximum destruction. I used to live there, I told Claes that, and he did this.) In what ways does Hödlke's revolving door break up this verticality? Does Raoul Hausmann's Call to Fantasy sum up what I've been saying? Is he a mere Dadaist, or is Dada perhaps a sort of realism or more? And is it just a world of costs in which we live?

A HOUSE OF STEEL
 IN A DESERT
 USING ALL AVAILABLE LIGHTING
 INHABITED BY FRENCH AND GERMAN SPEAKING PEOPLE

A HOUSE OF GLASS
 IN A DESERTED FACTORY
 USING ALL AVAILABLE LIGHTING
 INHABITED BY COLLECTORS OF ALL TYPES

A HOUSE OF SAND
 BY THE SEA
 USING CANDLES
 INHABITED BY VERY TALL PEOPLE

A HOUSE OF BROKEN DISHES
 IN DENSE WOODS
 USING NATURAL LIGHT
 INHABITED BY VARIOUS BIRDS AND FISH

A HOUSE OF SAND
 AMONG HIGH MOUNTAINS
 USING NATURAL LIGHT
 INHABITED BY VARIOUS BIRDS AND FISH

A HOUSE OF STEEL
 IN A DESERTED CHURCH
 USING ALL AVAILABLE LIGHTING
 INHABITED BY PEOPLE WHO SLEEP VERY LITTLE

A HOUSE OF MUD
 IN A COLD, WINDY CLIMATE
 USING ELECTRICITY
 INHABITED BY COLLECTORS OF ALL TYPES

A HOUSE OF WOOD
 INSIDE A MOUNTAIN
 USING NATURAL LIGHT
 INHABITED BY PEOPLE WHO SLEEP VERY LITTLE

A HOUSE OF STEEL
 IN A DESERTED FACTORY
 USING ALL AVAILABLE LIGHTING
 INHABITED BY FRENCH AND GERMAN SPEAKING PEOPLE

A HOUSE OF PAPER
 INSIDE A MOUNTAIN
 USING NATURAL LIGHT
 INHABITED BY FISHERMEN AND FAMILIES

A HOUSE OF STEEL
 AMONG SMALL HILLS
 USING ELECTRICITY

A HOUSE OF GLASS
 IN A PLACE WITH BOTH HEAVY RAIN AND BRIGHT SUN
 USING ALL AVAILABLE LIGHTING
 INHABITED BY HORSES AND BIRDS

A HOUSE OF WEEDS
 IN AN OVERPOPULATED AREA
 USING NATURAL LIGHT
 INHABITED BY LITTLE BOYS

A HOUSE OF WEEDS
 BY A RIVER
 USING ALL AVAILABLE LIGHTING
 INHABITED BY LOVERS

Geoff Hendricks 1967

PROJECTS FOR THE NEW YORK CITY AREA

1. Dig up the pavement and plant a dense forest over the full length of the following Manhattan streets:

 Broadway Fifth Avenue

 125 Street 42 Street 14 Street

 Canal Street The Bowery.

2. Paint the surfaces of New York City so that they correspond exactly to the respective colors on the current edition of any detailed, official map of the city. Take an aerial photograph in color when the paint is dry. Then repaint all the surfaces with sky, and take another aerial photograph.

Geoff Hendricks 1967

ONE YEAR EVENT

Construct a conveyor belt from Detroit to
Philadelphia.

Place all the new cars for that year on the
belt.

Send the cars into Philadelphia's new $3,000,000
car-shredding plant.

Truck the shredded material back to Detroit
in a solemn procession along the Interstate
Highway System.

FLOATING CITIES

Cities like clouds -- self-contained units -- free-moving -- shifting back and forth high over the landscape and reflecting the surrounding sky from their surfaces.

A THOUGHT

Evacuate a metropolitan area. Allow each person to take only one small overnight case of possessions. Take everyone to a great network of shallow lakes where they will bathe and dine at long tables on the shore and then be at liberty to walk in the country-side.

While the population is away, the whole city is covered with plastic foam, obliterating the old environment. On top of this foam the structures of the new city will grow -- plastic bubbles that would evolve in groups of various random patterns like the stones on the beach or the clouds in the sky.

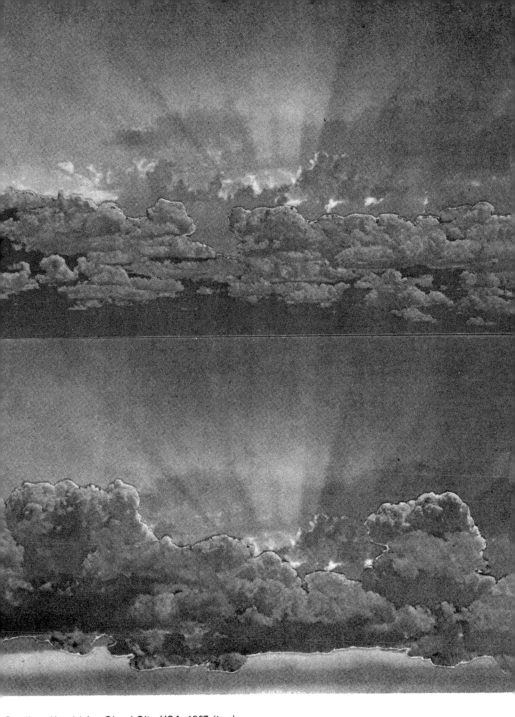

Geoffrey Hendricks, Cloud City USA, 1967 (top)
A floating metropolitan area for Dick from Geoff, Autumn 1967 (bottom)

Geoff Hendricks 1967

JUNK YARD NATIONAL PARK

A Proposal

It shall be proposed to the Congress of the United States of America that the most extensive area of junk yards in the New York / New Jersey metropolitan area be acquired by the federal government in perpetuity as an active, working junk yard. Just as our national forests grow and change, so should this junk yard. The natural beauty of the yard will be enhanced by the addition of new junk and the disintegration of the old

CAPTION 11

Compression – the smallest building, the smallest activated space to do the given thing perfectly. The need to do the most with the least, for its own sake, perhaps, as an aesthetic. Or because of necessity, perhaps to control costs. Either way, to activate minimal amounts of material or space in a maximal way. Fuller: the dodecahedron approaching a sphere, the area including a given volume with the minimal surface area. In music, the arrangement of a highly complex sound produced by a minimum number of instruments or unusual analog devices. The sense of efficiency rather than cost. The sense that so much is there, so much. Can one impress so much with opulence as with appropriateness? If one wanted to impress with opulence, how little would it take to do it? How small an edifice can be built and still be perfect? For what can a structure be perfect? And for how many things? How much can we do with Scotch Tape? Can buildings be like that? And still be livable?

Compression – the smallest building, the smallest activated space to do the given thing per-fectly. The need to do the most with the least, for its own sake', perhaps, as an aesthetic. Or because of necessity, perhaps to control costs. Either way, to activate minimal amounts of material or space in a maximal way. Fuller: the dodecahedron approaching a sphere, the area including a given volume with the minimal surface area. In music, the arrangement of a highly complex sound produced by a minimum number of instruments or unusual analog devices. The sense of efficiency rather than cost. The sense that so much is there, so much. Can one impress so much with opulence as with appropriateness? If one wanted to impress with opulence, how little would it take to do it? How small an edifice can be built and still be perfect? For what can a structure be perfect? And for how many things? How much can we do with Scotch Tape? Can buildings be like that? And still be livable?

Special areas shall be maintained, such as the field of gutted cars, the old tire lot, the mountain of scrap metal, the slag heap, etc.

Educational displays, signs, trails, and adequate parking shall be provided in appropriate locations, and the park shall be staffed by professional junk men who are capable of conserving the special character of this aspect of the American landscape.

THREE COMPLEMENTARY CONCEPTS

The Life-Stone -- a sepulchre-like pit with trap door, one space per person, marked by a simple headstone...

The Bruder -- a shallow, conical hover on a central post, with overhead radiant heat and indirect lighting sources in radial ceiling gills, and a platform floor...

The Hologram House -- walls, roof, and floor projected in three dimensions to define a living or working space...

The Life-Stone is the logical outcome of the pressure of expanding population, diminishing apartment sizes, the high cost of labor and materials, the tendency to conformity and standardization, the intensifying struggle to maintain personal privacy and ownership rights, and the phenomenon of the fallout shelter. It is the basic dwelling; a triumph of individualism. Although the chamber is invariably unfurnished and unadorned, some slight variation in headstone markers is anticipated to satisfy idiosyncratic differences, and status cravings will be pacified through a system of preferential locations.

Precast concrete. Stone.

The Bruder, however, reflects another aspect of our polarizing
society: the need for an unrestricted and wholly communal open area
which can be both meeting place and living quarters--a fluid concept
that will be accentuated as leisure time increases and the artificial
barriers between working and playing fall away. Like the Life-Stone,
the Bruder is without furniture or adornment, but it is also without
walls or confinement of any kind, and hence without privacy, all
aspects of life and social behavior taking place in full view. Here
the de-emphasis of personal property is total, the confinement of
the family unit is dissolved, and state surveillance, while facilit-
ated, actually becomes unneccessary in the prevailing climate of free
and joyous brotherhood and cooperation toward shared goals.

Cone, molded plastic on a re-
inforced concrete pole.
Platform, resilient plastic.

Both these are urban concepts. Each, in its way, contributes to the
anonymity so preciously regarded in the city. Hologram houses might
be used either as office space (a further urban application) or as
country retreats from city attrition. Two great characteristics of
today's culture are the strength of appeal of the visual (seeing is
believing), and the appetite for novelty (so what else is new). This
house, which consists entirely of filmed, projected light, achieves
reality and depth only by means of the optical sense. Purely illus-
ory, it is capable of transformation as frequently as the owner desires
to expose a new image to replace the old, whereas moving day may be
accomplished by means of a coat pocket or a stamped envelope. Here
is full scope for man's urge to elaborate and vary his surroundings.
No detail of elegance or comfort need be spared.

Laser light.

CAPTION 12

Locale – to be there and to use what is there. To use difficult-to-work materials when labor is cheap and needs work (the sidewalks of Mexico City or Rio de Janeiro). To use cheap materials, easy to work, where labor costs are high and skills are low (New York City). To use local or light-weight materials where transportation costs are high (Juneau, Alaska or San Juan, Puerto Rico). To build not where one must, necessarily, but often where one wants to, by adapting what one wants to build to just where one wants to be.

Can't we get rid of this emphasis on aluminium sidewall construction and pierced concrete technology? Can houses be made of pressed garbage? Gasoline was once a by-product of the kerosene industry and was burned as waste. Weren't there good things happening by learning to adapt it? What are we throwing away that would help us live with our locales? In any sense is Djakarta a fiasco for not looking like Java? Is ornament always wasteful? Can it be a camouflage? Are white adobe farmhouses primitive? Should there be zoning regulations against them? Should zoning and building codes reflect their locales beyond requirements for termite inspections or number 6 wiring, minimum? Are cities built by giants (or is this ironic?)? Or by city hall? Are architects corporate entities like Eichmann? Or should they be held personally responsible for their buildings, and required to sign them professionally and publicly?

Robert Filliou
14 Av. de Verdun
06 Villefranche-sur-Mer

24-10-68

Hi ho Wolf

This is for your and Dick's anthology of architectural projects.
I have 3 propositions to make.

The first one has to do with urbanism in general. Since it is
agreed by everyone that " le spectacle est dans la rue " why not
take this fully into account while planning new towns. The general
idea would be to offer people the best viewpoint and perpective from
which to enjoy the show that goes on permanently around them.

There must be lots of places for people just to sit and watch.
The streets they are facing must be of changeable size and shape.
For instance, at times they can be so narrow that people have to walk
them one after the other, in indian file. Then they would widen and
several people can walk abreast. There might be overpasses over
squares, one for each direction taken, so that passer-byes can look
at each other, and be looked at from below, and/or above. There
would be no museums, and things of this type. Artworks could be seen
in store windows, on street level. Performances of all sorts also.
(why fill storewindows with things that can be seen by entering the
shop anyway?).

Another thing to develop is what I call " the Erotic Sidewalk 2".
Through some electronic devise enbedded in the sidewalk, men and
women can get sexual gratification when they see women or men they
fancy walk by. Think also of the facial expressions, and physical
contorsions, that would follow. What a show for those who are resting
between orgasms!

The two last propositions have to do with the actual building of
city and country residences.
 buildings
In cities, houses could have the shape of their street-
number: 1, 2, 3, 8,... 11....... 254, etc..... It would
give a great deal of variety in each street. Monotony between different
streets could be avoided by using different shapes for the numbers
(there exist many in typography).

Country houses - frequently secondary residences - where the same
people tend to stay a long time, could giventhe shape of the face, or
the arm, or the leg, or the prick, or the cunt, etc..., of one
of the persons living in it.

Well, that's it for today, baby.

 yours R.Fillion

Robert Filliou, 1968 (Drawing by Stefan Wewerka)

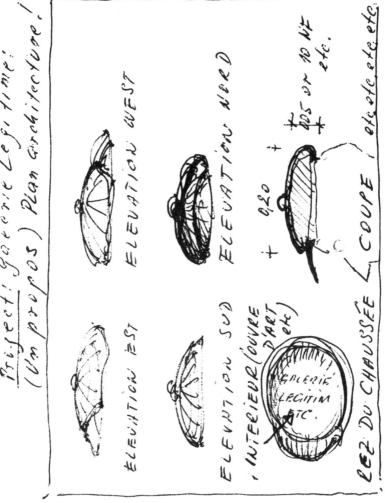

Project! Galerie Légitime!
(Un propos) Plan architecture!

ELEVATION WEST

ELEVATION NORD

+ 0,80 +
005 or 10 NF
etc.

COUPE! etc.etc.etc.etc.

ELEVATION EST

ELEVATION SUD

INTERIEUR (ouvre D'ART etc)

GALERIÉ
LÉGITIM
ETC.

REZ DU CHAUSSÉE

§7 Build any place, any size
and any material.
(enclosed miniature model.)

move

Ay-o, 1966

TACHISTIC ARCHITECTURE

GROUND-PLANS OF BUILDINGS

ARE TAKEN FROM ACCIDENTAL SPOTS,

BLOTS.

TWO STRUCTURES
by
Frances Starr

THE STRUCTURE OF BELIEF

Convert all churches into low and middle income housing
Unit rentals computed by dividing costs plus maintenance by floor space
Tenants do renovating
Costs plus labor credited toward their rent
End of religious subsidy increases real estate tax revenue making possible a decrease in income tax
The program is voluntary
Each congregation votes as to whether it will participate
THE STRUCTURE OF DISBELIEF

THE STRUCTURE OF DISBELIEF

An eternal frame around the grave of Lee Harvey Oswald
The grave itself is a 12 foot high block of light from laser beams
A five foot wide corridor of darkness surrounds the grave
A wall of light 12 feet high one foot thick surrounds this Visitors enter through the wall of light
Benches in the frame of darkness where visitors contemplate personal & public injustice & guilt & their inter-relationship
THE STRUCTURE OF BELIEF

PHILIP CORNER

Prefer to walk with feet

 going in to the places where

they have not cleared away. How ridiculous that temperature should

 hang-up modern transports —— Refuse

 to have a house where there's been a bulldozer. Evidently, most evident-

ly, They will have to bring everything down and put everything up.

(We ought to be indoors without leaving out-doors) All to favor living
 plants

School architecture ; not buildings. While someplaces legs are able And

flying for movement is notathing solid .

 Let the functions be perfect, extremes of the natural weather

 occur'd every where "for personal pleasure"/what
 follows
 will be
 detail.

Dear Wolf,

am sending a little concentrated city planning came up this week-end north of Boston. I'd been thinking (not specifically for this book) of a detailed investigation of the basic needs of transport, schools & homes, etc. I think I've got the essence in this paragraph, a presage of things to be forthcoming Could you add it to other page? Dick suggested might not be too late.

nice fellts? I would like to hear from you

Phil

Systems – a taste and need for anarchy producing its opposite, a taste and need for order. And vice versa. Neither being achieved, but the pulsing back and forth being the life of the game. Positive and negative, minus and plus, black and white, on and off. Cybernetics. The coding of these interplays. Architecture as willful imposition, architecture as harmonious ecology. Architecture of the past being the acceptance of one or the other. Architecture transcending itself, into design environment, when both polarities are accepted. The whole of the information consisting of the array of the two extremes, rather than the intensities of one or the other, the old idea of "definitiveness." The superiority of the digital computer over the analog computer. The master planning being a system of appropriateness for the need at hand. Shelter calling now for one thing, now for another. Structures intended to be viewed from outside calling for something else. The flow of people, the height of mountains, the degree of centralness or remoteness, all measurable though variable, requiring thinking in human and mechanical terms. Inventorying them.

Corner and Ben. Composers of music and events. Both inclined towards the anarchy pole, like being born on an odd-numbered day of the month and not an even-numbered day. Do systems include this? How about a rumpus room? How about a city with only rumpus rooms? How about another, quiet city with only gentle sounds and gardens? And another with clang and clatter and the more boisterous order of things? Where might each be placed? Can one live in commuting distance of each?

CAPTION 13

Systems – a taste and need for anarchy producing its opposite, a taste and need for order. And vice versa. Neither being achieved, but the pulsing back and forth being the life of the game. Positive and negative, minus and plus, black and white, on and off. Cybernetics. The coding of these interplays. Architecture as willful imposition, architecture as harmonious ecology. Architecture of the past being the acceptance of one or the other. Architecture transcending itself, into design environment, when both polarities are accepted. The whole of the information consisting of the array of the two extremes, rather than the intensities of one or the other, the old idea of "definitiveness". The superiority of the digital computer over the analog computer. The master planning being a system of appropriateness for the need at hand. Shelter calling now for one thing, now for another. Structures intended to be viewed from outside calling for something else. The flow of people, the height of mountains, the degree of centralness or remoteness, all mensurable though variable, requiring thinking in human and mechanical terms. Inventorying them.

Corner and Ben. Composers of music and events. Both inclined towards the anarchy pole, like being born on an odd-numbered day of the month and not an even-numbered day. Do systems include this? How about a rumpus room? How about a city with only rumpus rooms? How about another, quiet city with only gentle sounds and gardens? And another with clang and clatter and the more boisterous order of things? Where might each be placed? Can one live in commuting distance of each?

Architecture Project 1963

Dont throw anything away
for 70 years.
Keep it. live with it.
put it in your room house,
appartement or garden -

Bu.

Architecture Project 2

LIVE WITH NOTHING 1966

" Socrates was very proud of having very few posetions of
his own - All he had he could carry in a small
bundle - among these posetions was a tumbler to
drink with - One day he was thirsty he went
to drink at the River - there he saw a small
boy drink by joining his two hands together
like a cup - When Socrates saw that .
he threw his tumbler away . ————
 Ben

Architecture Project 3 1966

In every country a big wild territory should be
given to all those who are not satisfyed with
society – young delinquents, unadapted peoples
beatniks – anarchists etc – in This Free Territory
the Country law shall not be enforced or valid
It would be interesting to see after some time
how life has organised itself –

for instance what ~~does this region~~ will the <u>architecture</u>
<u>look like</u> –

Ben

Expensive _____ 10 January 1969

architecture project for Eric Anderson

a very ordinary House built in
an ordinary Working class
District with the following
materials and ellements

the Walls shall be built in pure
18 Carats gold Briks –

the Windows in pure Cristal

the Doors in pure platine

The Wallpaper shall be made of
10 and 100 $ bills for 1 room
and 100 £ bills for another room

the WC floor shall be covered
with Rubys every inch

the bathroom floor shall well
be made out of pure opale
or quartz

The roof of the living Room
will be incrustaded with
millions of Diamonds —
Carpets shall be of
Chinchila or Vison
The kitchen Walls will
be in Saphire and Emeralds
& shall give precisean
for furniture only after the
house is built
Thanks Ben

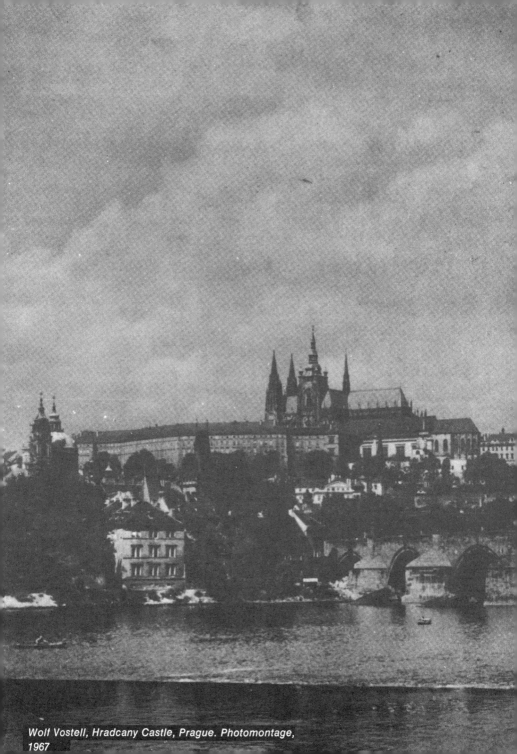

Wolf Vostell, Hradcany Castle, Prague. Photomontage, 1967

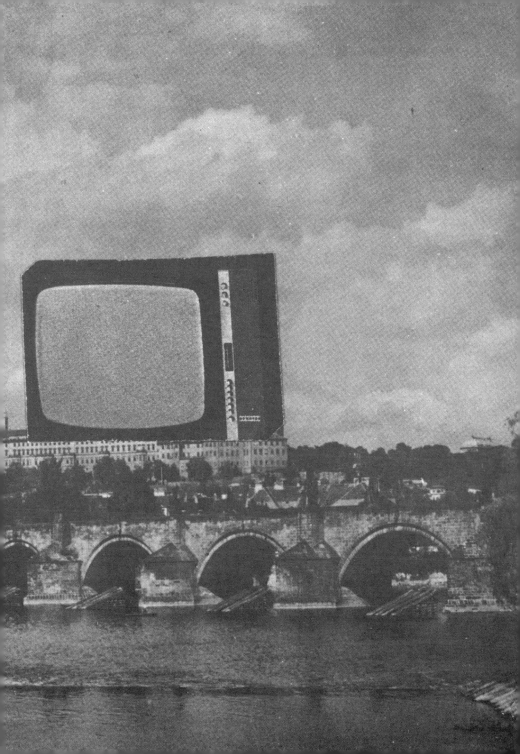

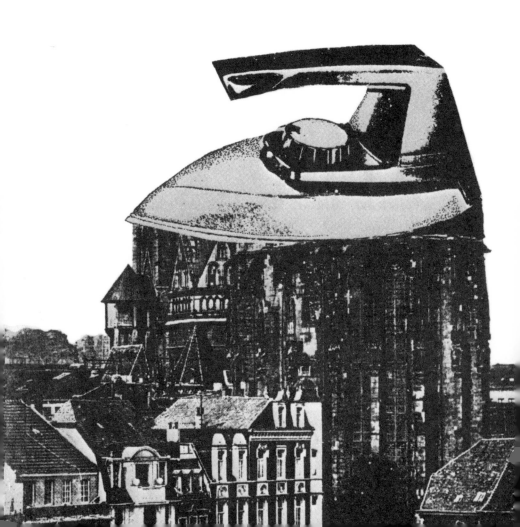

Wolf Vostell, Proposal for altering
the Cathedral of Aachen, 1967

MANIFESTO FOR A POLY MULTI MIXED MEDIA UNIVERSALITY
(ELECTICISM HAPPENING ROOM)

I. ULTIMATE GOALS

A SIMULTANEOUS COMMUNICATION EVERY SINGLE
SECOND WITH ALL THE THOUGHTS AND ACTIONS
IN THE WORLD !

B A RECEIVER AND A TRANSMITTER ARE ATTACHED
TO THE HUMAN BRAIN TO RECEIVE AND BROAD-
CAST THOUGHTS TO AND FROM ALL THE PEOPLE
IN THE WORLD OR WITH ANY ONE PERSON IN
ANY ONE PLACE !

C RADIO AND TELEVISION SETS WILL BE UNNEC-
ESSARY ! VIA THE BRAIN EVERY HUMAN BEING
ANYWHERE CAN BE REACHED AND SIMULTANEOUSLY
INFORMED OF ACTION BECAUSE HE IS PRESENT
ALTHOUGH GEOGRAPHICALLY REMOVED !

D EVERYWHERE IN THE WORLD THERE ARE TUBES
OR SPRAYING CANS EVERY 500 YARDS FOR PRO-
DUCING AN IGLOO-LIKE CONSTRUCTION AT ANY
TIME AND WITHIN SECONDS WITH EXPANDING
FOAM RUBBER OR BY BLOWING UP NEW MATERIALS !
EVERYONE CARRIES HIS HOME AROUND IN A CAN
A SUPPLEMENTARY SERUM DISSOLVES THE CON-
STRUCTION WITHIN SECONDS WHICH WILL MAKE
THE TRADITIONAL MASSIVE CITY SUPERFLUOUS !

E COMPUTERS SANITARY FACILITIES MEDICINE AND
FOOD ARE BUILT INTO CLOTHING AND CAN BE
THROWN AWAY AFTER USE !

<u>MANIFESTO FOR A POLY MULTI MIXED MEDIA UNIVERSALITY</u>
(ELECTICISM HAPPENING ROOM)

1. ULTIMATE GOALS

A SIMULTANEOUS COMMUNICATION EVERY SINGLE
SECOND WITH ALL THE THOUGHTS AND ACTIONS
IN THE WORLD !

B A RECEIVER AND A TRANSMITTER ARE ATTACHED
TO THE HUMAN BRAIN TO RECEIVE AND BROAD-
CAST THOUGHTS TO AND FROM ALL THE PEOPLE
IN THE WORLD OR WITH ANY ONE PERSON IN
ANY ONE PLACE !

C RADIO AND TELEVISION SETS WILL BE UNNEC-
ESSARY ! VIA THE BRAIN EVERY HUMAN BEING
ANYWHERE CAN BE REACHED AND SIMULTANEOUSLY
INFORMED OF ACTION BECAUSE HE IS PRESENT
ALTHOUGH GEOGRAPHICALLY REMOVED !

D EVERYWHERE IN THE WORLD THERE ARE TUBES
OR SPRAYING CANS EVERY 500 YARDS FOR PRO-
DUCING AN IGLOO-LIKE CONSTRUCTION AT ANY
TIME AND WITHIN SECONDS WITH EXPANDING
FOAM RUBBER OR BY BLOWING UP NEW MATERIALS !
EVERYONE CARRIES HIS HOME AROUND IN A CAN
A SUPPLEMENTARY SERUM DISSOLVES THE CON-
STRUCTION WITHIN SECONDS WHICH WILL MAKE
THE TRADITIONAL MASSIVE CITY SUPERFLUOUS !

E COMPUTERS SANITARY FACILITIES MEDICINE AND
FOOD ARE BUILT INTO CLOTHING AND CAN BE
THROWN AWAY AFTER USE !

F THE SURFACE OF THE EARTH CAN BE CRUSTED
OVER IN WHITE OR IN COLORS FOR US TO LEAVE
TRAILS TRACES OR MARKS OF OUR EXISTENCE !

G EVERYONE RECEIVES A SUPPLY OF LASER BEAMS
FOR CREATING DE-COLL/AGE ARCHITECTURE BY
MELTING AND DRILLING HOLES AND CAVITIES
SEVERAL MILES DEEP IN ANTARCTIC ICE !

H EVERYONE SHOULD STUDY PSYCHOLOGY AND MEDI-
CINE AND BE ABLE TO ANALYZE HIMSELF !
MOBILE TEAMS OF DOCTORS WILL TREAT PEOPLE
DAILY AND FOR FREE !

I EXCEPT IN A VERY FEW PLACES OF MANUFACTURE
PEOPLE WILL DEVOTE THEMSELVES TO LOVE ENTER-
TAINING AND SERIOUS GAMES IN ORDER TO
EXPAND THEIR AWARENESS OF LIFE AND EXISTENCE !

J EDUCATION WILL BE CONDUCTED BY THE MOST
PROGRESSIVE PEOPLE AND NO LONGER BY THE
MEDIOCRE !
PROGRESSIVITY AS QUALITY !

Wolf Vostell, 1967
Manifesto
Technische Hochschule, Aachen

F THE SURFACE OF THE EARTH CAN BE CRUSTED
OVER IN WHITE OR IN COLORS FOR US TO LEAVE
TRAILS TRACES OR MARKS OF OUR EXISTENCE !

G EVERYONE RECEIVES A SUPPLY OF LASER BEAMS
FOR CREATING DE-COIL/AGE ARCHITECTURE BY
MELTING AND DRILLING HOLES AND CAVITIES
SEVERAL MILES DEEP IN ANTARCTIC ICE !

H EVERYONE SHOULD STUDY PSYCHOLOGY AND MEDI-
CINE AND BE ABLE TO ANALYZE HIMSELF !
MOBILE TEAMS OF DOCTORS WILL TREAT PEOPLE
DAILY AND FOR FREE !

I EXCEPT IN A VERY FEW PLACES OF MANUFACTURE
PEOPLE WILL DEVOTE THEMSELVES TO LOVE ENTER-
TAINING AND SERIOUS GAMES IN ORDER TO
EXPAND THEIR AWARENESS OF LIFE AND EXISTENCE !

J EDUCATION WILL BE CONDUCTED BY THE MOST
PROGRESSIVE PEOPLE AND NO LONGER BY THE
MEDIOCRE !
PROGRESSIVITY AS QUALITY !

Wolf Vostell, 1967
Manifesto
Technische Hochschule, Aachen

Franz Mon
NOTES ON A LABYRINTHINE ARCHITECTURE

A house is a commodity. Think of the snail or the mole or the turtle, the stork, the honey-bee. None of them build houses and yet all of them are protected against wind and weather, sticks and stones, mice and men. A human being, however, frailer than they and highly susceptible to coughs and loss of hair, erects shelters and hires men to protect him. This is reason enough to give careful consideration to what we need beyond a roof over our heads to ward off sunshine, starlight, locusts, ants, fruit peddlers, helicopters, and general feelings of discomfort. Let's start by collecting details: a pit, one two three four five bulges at the bottom, a hollow bulb, large enough to hold several people comfortably, stairs, several staircases with different step heights and widths, including at least one spiral staircase and one staircase with steps of varying heights, as well as apertures, apertures on all sides, up and down, open or glassed, not only windows, but also cracks, slits, crannies, holes, as well as broom-closets at various points, not only for brooms, not at all for brooms, very narrow and deep, and including one with room for a flagpole or a signal mast, and a very long one, possibly with several sharp joints, as well as several low rooms, where you bump your head on the ceiling if you've got one and if you're not a midget, as well as rooms where even a midget would bump against the ceiling, very bright because of innumerable round windows on the facing side.

Each house follows a ground-plan of motion. Most houses have truncated, staved, over-abbreviated ground-plans of motion. A house, no matter what its purpose, should not be seen statically when we recall its model, for it supplies the negative form of the human motions enacted in it. Since we spend most of our lives in houses, we have the right to have houses that comply with the body's desires for motion: e.g. climbing, rolling, spiraling – movements that are impossible or well nigh impossible in the usual house. There are movements possible only within a building and never outdoors, in a city, or in nature: movements contingent on the reflex of walls, ceilings, floors, concave or convex, rising or falling, narrowing or widening, on the resistance of steps or doors, on a direction through closed or open, curved or extended rooms, and it is only with such help that those movements can be invented and felt at all. The movements of the human body are prepared and accompanied by blueprints and imaginations of motion, and they continue when the body itself

is already at rest. They are developed and determined in accordance with each room and its groundplan of motion, while accentuating and articulating the latter. An absolute architecture – if one permits it for one moment at least as a mental experiment – admits two completely antithetical conceptions: a construction based on a geometrical or mathematical principle and whose elements are composed with no regard to walking or living, whose rooms can be, but are not necessarily, walked or lived in; a labyrinthine construction based on subjective desires for motion, meant secondarily for the eye, but primarily for the enactment of spatial and motion imagination. The latter is not necessarily guided by bodily comfort, in fact it might be best for the construction to follow a fanciful law at points that impede walking, like an Alpine wall or a flooded tongue of rock. The body not only wants to experience itself in its volume, its working points, its gravity and energy, it also carries about an environmental space derived from the unison of the bodily imagination and the experience of real space. All architecture worthy of the name is determined by such spatial phantasms, even though it may otherwise follow certain geometrical specifications. One need only check the two-sided stairway in a Baroque castle and the narrowing transition to a suite of rooms.

It is obvious that the mirror serves its original function as a device to bring the spatial imagination into play beyond the possible. And it is equally obvious that the color forms of the enclosing planes play a major role. For color has an imaginative motion-quality and can easily be experienced and reflected in a continuum with real bodily movement in a space. In our model of an absolute labyrinthine architecture, the surface color is a counterpoint to the spatial form: the color can simply confirm and strengthen the spatial form, it can differentiate, deny, and negate it. It can make the space tangible or intangible, reduce or enlarge it, bring it to a halt or transform it into torrential motion, strip it of its abstractness and turn it into a roll or an iron. The color intercepts the motion wishes of the body and makes them visible. A construction whose dimensions are somehow based on the human body turns into a kind of plastic painting-ground, whose system of measures is completely open and determined primarily by the color – with no detriment to the architectural quality. The latter is suspended and yet not contested. A house is no longer a house although it can be walked and lived in.

There is no pictorial technique or stylistic trend unsuitable for this painting-ground except for those insisting on the illusionist rendering of optical reality. Informal or abstract art, Op or Pop are all viable. The architectural locations – floor, ceiling, walls, corners, passages from room to room, bright spots, dark spots, etc. – are provocations dreamt up by painters. The superdimensional painting-ground of the edifice provides a continuous discontinuum because the spectator can perceive only sections of the whole while other parts move out of sight. There is no distance from which the whole becomes visible, an overall idea crystallizes only in the memory. The color forms can be covered by household utensils at certain points. Such contact is as viable as a contact with the architectural locations. Objects pass into the artificial web of functions without losing their practical function. They, too, can be coated with a color-form and become a painting-ground just like the the body of the edifice. Someday each of us will be applying the color-skins of his building and his objects according to his need and change them when he has to.

A more difficult problem arises with the plastic deformation of spaces, inherent in the function of a building as a painting-ground and the alterability of its color-skin. This will be possible with the desired ease only when the rigid conventional building-materials are replaced at least partially by synthetic materials, which are constantly liable to deformation. People are already working on such synthetics and on the corresponding technological processes. The color no longer has to reflect a rigid architectural structure; in fact, the latter will actively enter the process of color-form and change along with it. A labyrinthine architecture totally achieves its reality not only when its construction elements are transferable (the goal of presentday mobile architecture since the transfer can take place only within a cubic scheme), but also when it can be deformed in any way and in any direction, like a balloon, without being confined by specific basic geometric forms. The static difference between the functions of walls, ceilings, and floors will thus become less important. The varying loads of tension and pressure are balanced by a fortification of the material at the necessary points. Such a building exchanges the archetypal superiority of the "house" for the camaraderie of a suit or a notebook. A building is no longer a piece of property, it has become an existential material, a medium for a specific consummation of existence. In using it, we not only leave our traces, we also eventually transform it quite consciously into an agglomerate of our traces. It may thus get to be like a worn-out suit, but also

like a filled-up notebook. In any event, it has to be exchangeable and therefore as cheap to produce as a ready-made suit. Types are to be supplied, combinable like sectional furniture. Only the tenant gives them a form, of his choosing unless he prefers using them in the simple manufactured form. These edifices can be joined to conventional buildings or hung up in gigantic empty scaffolds to be erected in place of highrisers.

Living in movable, combinable, and deformable edifices is more mobile; but at the same time, social groups sympathizing with one another can come together more easily than is possible in the present system of living, and they can alter their make-up with no great trouble. The more rational system could thus, as an incidental result, create a greater social coherence than the traditional system can.

The highly private interior, allowing the most subjective deformations, demands an urban exterior, where for the sake of orientation, provocation, and in contrast to subjective accomplishments, the "signs of the times" appear not merely as symptoms – mass traffic, billboard plague, etc. – but in deliberately articulated signals, monuments, projections. The present urban landscape, which is neither urban nor a landscape, will become an artificial union of urban images. Since the public is the buyer (the quality being assured only by a relentless artistic freedom), it is at present hard to tell which agencies ought to take official and financial charge. Our miserable experiences with housing authorities and what they consider "art in architecture" makes us doubt their qualifications for such a dynamic task. Signal pictures, light and sound shows, mobile machine sculptures, object sculptures of colossal and unusual dimensions are already reflecting our civilization's material and demanding public and permanent installation rather than an occasional display or a museum hoarding. Their substantial value is negligible compared with their aesthetic and cultural communication-value. It is also conceivable that the advertising industry will recognize its surplus value, its free scope, which it obtains by its position between the business account a n d the general public, and by its responsibilities to both. Advertising has to reflect in its medium the "characteristics of the time," insofar as they are inherent in industrial production – and which aren't . . .?

It was proven long ago that the architecture of individual buildings as well as entire building conglomerates cannot enter traditional social representation because society itself is too divergent, it depends on a high degree of reflection, its level of consciousness changes too quickly for any architecture to follow, much less to lead, as was once the case, and finally because the signal phenomena no longer refer to the representation of a stable social order, they actually participate in its mobility: their "meanings" begin when they are conceived and realized, and they can be different in each individual case.

Architecture and city planning are contingent on the help, the correlative of more sensitive and variable arts, and the latter are already developing the media to fill out contemporary townscapes, not on commission but as a preliminary accomplishment.

There is a great enough probability that rival socio-political trends, which we have already sufficiently sampled, are undermining the realization. Yet it is still conceivable that somewhere in the divergent cultural organizations the offered unison will succeed and that artificial townscapes will arise, permitting and making transparent the features of civilizational productivity, mobility, massification, illusivity, indefinability, reflexivity, producing destruction, destroying production, publicly confronting contemporary man with his reality.

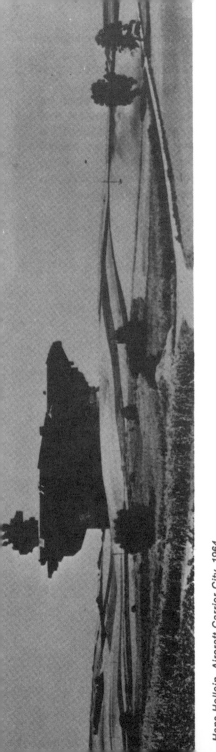

Hans Hollein, Aircraft Carrier City, 1964
(Coll. Claes Oldenburg)

Hans Hollein, Ore railroad freight car, 1963 (Coll. MOMA, New York)

Hans Hollein, Plan for Copenhagen, 1969

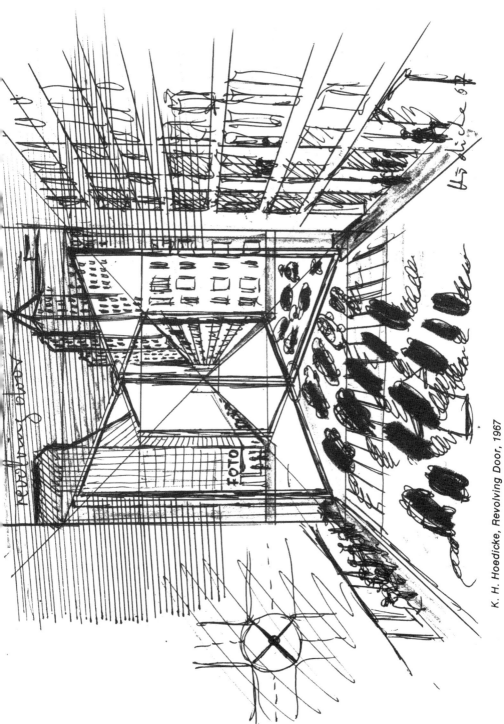

K. H. Hoedicke, *Revolving Door*, 1967

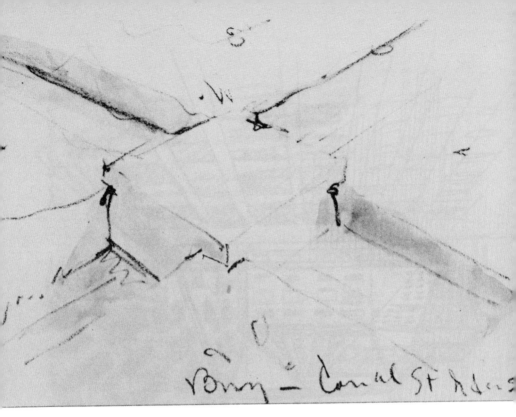

Claes Oldenburg, *Proposed Colossal Monument of Concrete Inscribed with Names of War Heroes, In the Intersection of Canal Street and Broadway, 1965*

Claes Oldenburg, Proposed Colossal Monument to Replace the
Washington Obelisk, Washington, D. C.: Scissors in Motion, 1967

Claes Oldenburg, Proposed Colossal Monument for Central Park, New York: Moving Pool Balls, 1967

AN APPEAL FOR FANTASY

What is labeled "urbanism" nowadays is far removed from the initial
ventures of the Dutch architects Oud and Rietveld.
Present-day urbanism stands under the sway of Le Corbusier, who was
inspired by naval constructions, by luxury liners.

The formula of today's architecture is nothing but the satisfaction
of the sedentary and residential needs of the citizen who seeks
nothing but peace and quiet and desires a certain level of comfort
(central heating, refrigerator, washing machine, TV set, etc.).

This is not the goal of a living architecture. Life is fantastic.
Let the architectural surroundings of man be equally fantastic.
The minimum vital is neither fantastic nor artistic.

What can we do? Urbanism has to be abandoned and forgotten, it is
merely an answer to a need, and not a living action. The beehive
system must be abandoned. Man is not a robot-insect. The architecture
of free conception has an unusual function, it is something other
than a disagreeable misfortune.

Why shouldn't architectonic fantasy be like rocks, crystals, coral,
and plants? And why shouldn't it surpass these forms with unusual
and superhuman forms of its own? This is the problem. And we must
solve it.

The architect is the man who makes the tecture of archetypes. Tec-
tonics of the ark. No habitat for habit, no crate for living called
a house.
You don't lock yourself up in a crate with four walls. Ark-tecture.
Architecture is everything, but not a cube.
Texture, tectonics, structure, adjusted to the variable temperature
of the human body. Architorture.
Let's get moving, away from architorture.

Man regards himself as intelligent. He has created an order of be-
havior that animals and insects also possess, at times to a superior
degree.
He invented technological progress and pleasure. He has missed a
great number of opportunities for imagination.

Ultimately man has accomplished nothing but the satisfaction of his most primitive needs. Self-protection against bad weather is a necessity.

Man has created various ways of building himself a shelter. Nowadays he crawls into so-called urban cells. What does he do inside them? He stands, he sits, and he lies down to rest.

Man has never succeeded in building a chair in which he can sit without his legs falling asleep. Man has never succeeded in building a bed in which he can sleep other than like a tamed animal. All of man's conveniences are merely the result of his laziness: he can't invent anything, because he doesn't want to be anything but practical. All devices for relaxation are nothing but instruments of torture.

Man in the astronautical era can no longer live in a concrete beehive. Give him a non-gravitational place to live in, where he can move at will, walk, lie down unhampered, with no supports and no springs. Farewell, chair, farewell, bed. No need for you anymore. And of course no more kitchens. Away with those American-style kitchens, plastic tiles, pictures on the walls -- NO, away with them! And away with overeating! A good cuisine and a good cellar. NO! Very little food, to stay slender and agile. Getting fat is punishable by law.

Hovering in an anti-gravitational capsule, and with no modern conveniences, for these are the mental laziness of idiots. The anti-gravitational space-capsules are suspended from scaffolds, climbing up and down these scaffolds is a necessary exercise for the circulation. The collection of individual free-floating capsules with their scaffolding has to be erected beyond present-day cities, the latter are unhealthy and unhygienic, they must be abandoned. They can be left to serve as offices and factories. Avant-garde man, however, must himself change the tectonics of the earth.

Our planet is in bad shape, full of useless baroque objects, unsold and unsaleable items from a prehistoric era. Consequently we need a planetary architecture beyond individual architecture. A new order and an Earth-Works-Plan. Let's get started!

Fantasy is the express enemy of sedentary life. Was there ever such a thing as an architecture of fantasy? No! Except for the astronomical constructions of prehistoric Peru, Mexico and India, every architecture has served only to satisfy the needs of "common sense." Even the Great Pyramid of Cheops is full of common sense. Well? Then everything has to be changed.

Especially the rotten teeth of the earth -- the Alps, the Himalayas, the Andes, the Cordilleras and other bizarre remnants and malformations of the earth.

The scientists wish to conquer the universe? They'll have to go about it in a different way.
What they lack is fantasy.
Sending human beings a few miles up from the surface of the earth is nothing. We have to shunt the earth from its orbit if we want to get to know the brother planets of our universe.
To do so, we have to create a society that functions, and we have to change the very architecture of the earth.
Instead of driving nations into war, we have to get them to create works of fantasy.

We must: empty the big cities of their inhabitants and relocate them along the high mountain chains. Plane down and smooth out the various peaks and jags into acceptable forms.
After planing and smoothing out all the completely superfluous mountains, there is other work to do.

Along these cleaned fishbones we
simple trenches, however, but tre
miles deep and, naturally, of me

This is also the solution to the
it will keep all humanity busy,
to do but wage war.

To sum up: we have to clear away
along them, and then, when every
12,000 atomic bombs in America a
inconceivable power in the mines

Just wait and see!
The earth will turn a somersault
go wherever we want it to go.

And thus we'll be able to visit
Without fail!

Inhabitants of the earth! Carry
There is no other solution!

have to dig trenches. Not just
nches a hundred or two hundred
idian length.

social problem, for fifty years
therwise men would have nothing

the high mountains, dig trenches
hing is completed: take the
1 the U.S.S.R. and detonate this
we have created.

it won't matter, the earth will

he brother stars in our universe.

1t this project.

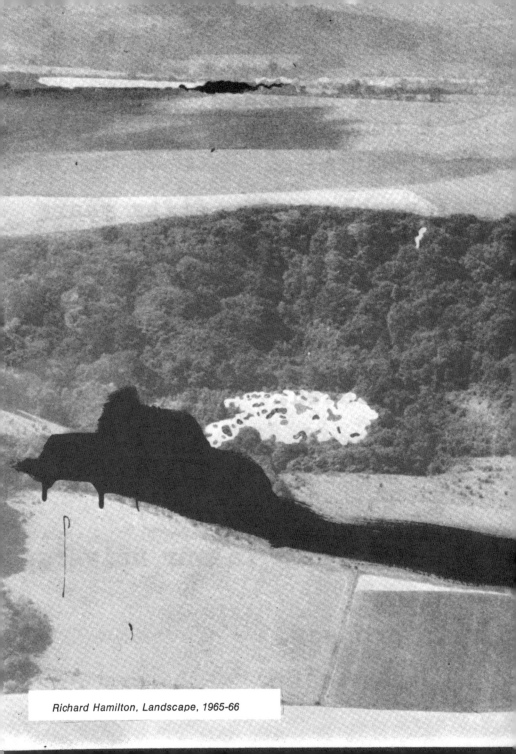

Richard Hamilton, Landscape, 1965-66

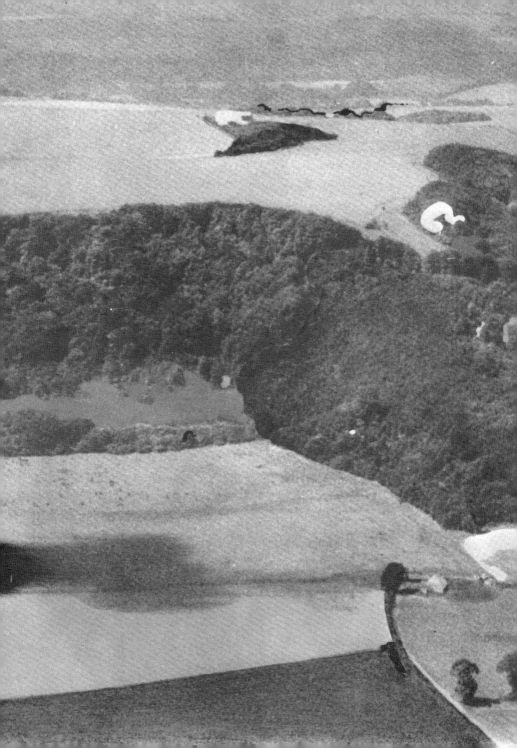

Gerhard Rühm, b. 1930 in Vienna
lives in Berlin

Claes Oldenburg, b. 1929 in Stockholm
lives in New Haven

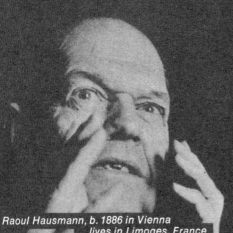

Raoul Hausmann, b. 1886 in Vienna
lives in Limoges, France

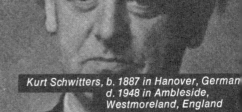

Kurt Schwitters, b. 1887 in Hanover, German
d. 1948 in Ambleside,
Westmoreland, England

Erich Buchholz, b. 1891 in Bromberg, Germany
lives in Berlin

Wolf Vostell, b. 1932 in Leverkusen, Germany
lives in Cologne

Bici Hendricks, lives in New York

Dennis Oppenheim, b. 1938 in Mason City, Wash.
lives in Brooklyn

Franz Mon, b. 1926 in Frankfurt, Germany
lives in Frankfurt

Carolee Schneemann, lives in New York

Ben Vautier, lives in Nice

Robert Filliou, lives in Dusseldorf

Stefan Wewerka, b. 1928 in Magdeburg, Germany
lives in Cologne

Dick Higgins, b. 1938 in Jesus Pieces, Cambridg
England

Addi Koepcke, b. 1928 in Hamburg, Germany
lives in Copenhagen

Lawrence Weiner, b. 1940 in the Bronx
lives in New York

Joseph Beuys, b. 1921 in Cleves, Germany
lives in Dusseldorf

Milan Knizak, b. 1940 in Czechoslovakia
lives in New York

Michael Heizer, b. 1944 in Berkeley, Calif.
lives in New York

Jan Dibbets, b. 1914 in Holland
lives in Amsterdam

K. H. Hoedicke, b. 1938 in Nuremberg
lives in Berlin

Jan Jacob Herman, b. in New York
lives in San Francisco

Jean Tinguely, b. 1925 in Freiburg, Switzerland
lives in Paris

Daniel Spoerri, b. 1930 in Galati, Romania
lives in Switzerland

Diter Rot, b. 1930 in Hanover, Germany
lives in Reykjavik and Dusseldorf

Ay-o, b. 1931 in Ibaragi, Japan
lives in Kentucky

Frances Starr, lives in New York

Alison Knowles, lives in New York

Philip Corner, b. in New York
lives in New York

Douglas Huebler, b. 1924

John Cage, b. 1912 in Los Angeles
lives at Stony Point, N. Y.

Richard Hamilton, b. 1922 in London
lives in London

Geoffrey Hendricks, b. 1931 in Littleton,
New Hampshire
lives in New York

Buckminster (Bucky) Fuller, b. 1895 in Milton,
Massachusetts
lives in U. S. A.

Hans Hollein, b. 1934 in Vienna
lives in Vienna and Dusseldorf

Pol Bury, b. 1922 in Haine-Saint Pierre, Belgium
lives in Fontenay aux Roses, France

Photo Credits

CAPTION 14

Questions unanswered and questions unasked – not one of the projects in this entire book dealing primarily with the problems of race or of nationality, the two great questions of our time, to judge by the effort expended on them. Are these questions being avoided?
That man desires to be diverse is an axiom. In a world evenly divided between red-headed families and brunette ones, with the former and the latter speaking the same language originally, it would not take long for them each to develop a mystique, for the one to wish to speak differently from the other, for new languages to form, for a custom among the red-heads for growing moustaches, perhaps, while the brunettes would wear their hair longer and shave their faces entirely. Identifying oneself as a member of a group is a means of declaring one's individuality and uniqueness.

This is often more clear to artists than to other members of society, since it is part of their job to transcend parochial interests. With the exception of Gerhard Rühm dealing so specifically with Vienna, therefore, this book is virtually unique among architecture books. Most list endless and patronizing "projects for the redevelopment of Harlem", for "the Gorbals", for the "favelhas", for this or that slum or non-slum. Here there is only a grab-bag of ideas to offer and of questions. Questions which, if they are not answered before construction begins in the rebuilding of our physical world, are going to cause even greater violence in the future world in which the present problems of race and nationality will have become either mere decoration or academic.

Fantastic Architecture
© 2015 Primary Information

ISBN: 978-0-9906896-0-7

Printed in an edition of 3,000

Primary Information
45 Main Street, Suite 515
Brooklyn, NY 11201
www.primaryinformation.org

This publication is made possible through the generous support of
The Graham Foundation for Advanced Studies in the Fine Arts.

Primary Information is a 501(c)(3) non-profit organization that receives
generous support through grants from The Andy Warhol Foundation for
the Visual Arts, the Greenwich Collection Ltd, the Foundation for
Contemporary Arts, the New York State Council on the Arts, the
Stichting Egress Foundation, and individuals worldwide.

Primary Information would like to thank the Estate of Dick Higgins, the
Estate of Wolf Vostell, Electronic Arts Intermix, Michael Eby, Ryan
Haley, Aaron Kaplan, Daniel Löwenbrück, Barbara Moore, David
Platzker, Printed Matter Inc., and Julie Schumacher Grubbs.